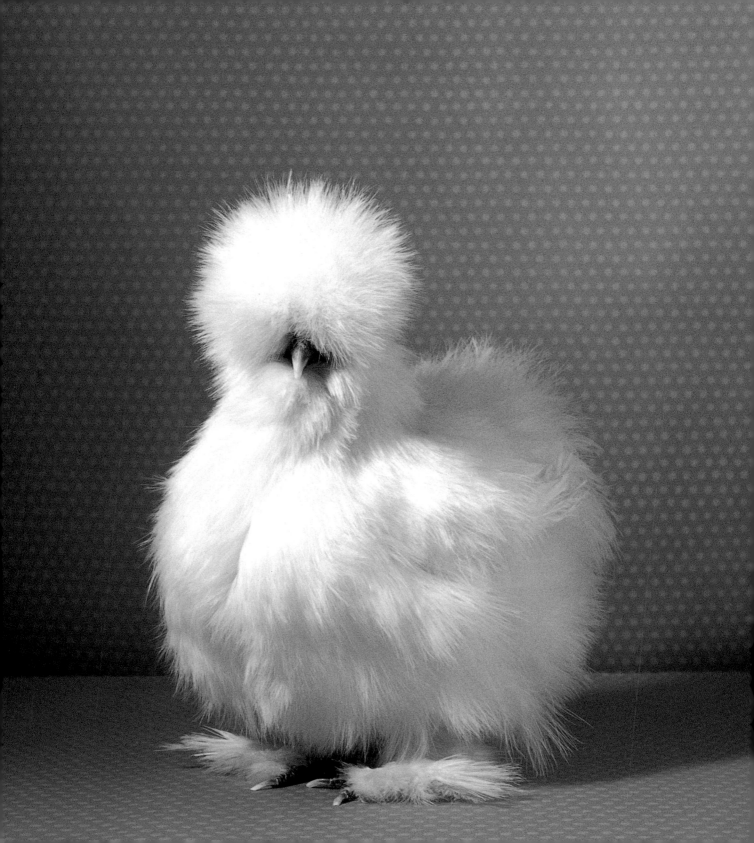

PHOTOGRAPHS BY TAMARA STAPLES

Essay by Ira Glass

Text by Christa Velbel

CHRONICLE BOOKS
SAN FRANCISCO

THE FAIREST FOWL

Portraits of Championship Chickens

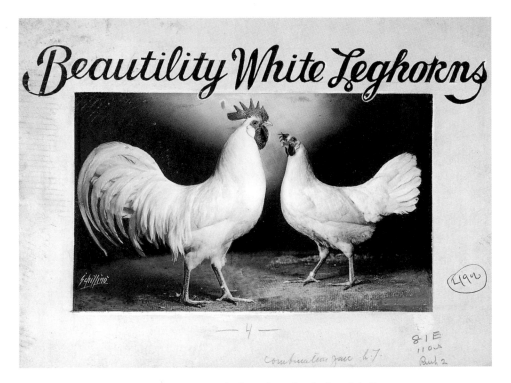

Early 20th-century chicken photo by Arthur Schilling.

Additional breed identifications: p. 4, Bearded White Silkie Pullet; p. 102, White Cornish Cockerel; p. 105, Dark Brahma Hen; p. 107, mixed breed.

Additional photo credits: Dennis Ayuson, pp. 36, 37 middle left, 87 top left; Bill Newell, pp. 87 bottom left, 100–101, back flap; provided by Bill Wulff, *Poultry Press,* photo by Arthur Schilling, p. 6; Burt Gaude, back cover.

New feathers and all globe illustrations on pp. 24–98 by Scott Piper.

Text on pp. 16–17, 24–98, and images on pp. 2–3 from the *American Standard of Perfection,* 1998 edition; images on p. 16 developed based on imagery in the *American Standard of Perfection,* 1983 edition; text on pp. 18–19, and images on pp. 10–12, 14–15, 18, 19 from the *American Standard of Perfection,* 1930 edition. Selected feather illustrations on pp. 24–98 from the *American Standard of Perfection,* 1910 edition. Used by permission of the American Poultry Association.

"Trying to Respect a Chicken" was broadcast on the public radio program *This American Life,* produced at WBEZ in Chicago and distributed by Public Radio International. Produced by Julie Snyder. Copyright © by Ira Glass and WBEZ Chicago.

Library of Congress Cataloging-in-Publication Data available.

ISBN: 0-8118-3137-X

Manufactured in China.

Designed by The Grillo Group, Inc.
www.grillogroup.com

Distributed in Canada by Raincoast Books
9050 Shaughnessy Street
Vancouver, British Columbia V6P 6E5

10 9 8 7 6 5 4

Chronicle Books LLC
85 Second Street
San Francisco, California 94105

www.chroniclebooks.com

ACKNOWLEDGMENTS

What comes first in this chicken book is a dedication to my uncle, Ron Simpson, who introduced me to the poultry shows and encouraged me to come back for more with a camera. Uncle Ron's love of the hobby inspired this book. He is a great breeder of show poultry, and he's the salt of the earth.

A number of people helped me in so many ways: Pat Malone, president of the American Poultry Association, editor and publisher Bill Wulff of *Poultry Press,* Dennis Ayuson, Todd Rosenberg, Michael Greenberg, Lise Thomsen, and John Blehm. All the breeders who cherish these chickens have earned my thanks, especially those who so graciously allowed me to photograph their birds. Special thanks to the folks who spared the time to be interviewed: Mary Wagner, Todd Kaehler, Ken Herring, Carolyn Krause, Dick and Thola Waldau, as well as the aforementioned Pat Malone and Bill Wulff. Thanks to Bill Newell and Dennis Ayuson for some of the black-and-white photography from the shows. Thanks also to Christa Velbel for her spirited approach to describing the birds in words.

And finally, let me single out Maria Grillo and The Grillo Group for making what you hold in your hands a reality. Maria's enthusiasm for my chicken photographs was the source of this book's design. Maria, along with designer Julie Klugman, Carla González, and the rest of The Grillo Group staff, have my deepest affection and thanks. They are the standard of perfection for design in Chicago.

Visit the chickens at www.tamarastaples.com

—*Tamara Staples*

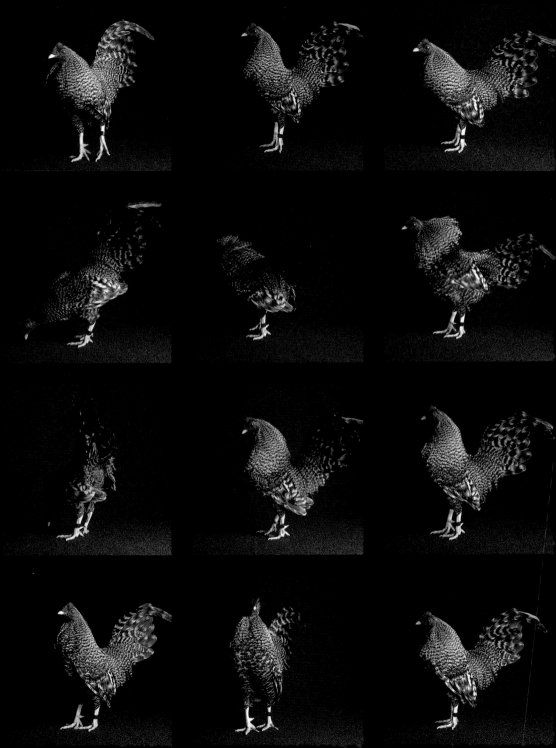

THE WORLD OF CHAMPION CHICKENS

Chickens this amazing don't just happen. People help them along—breed them, nurture them, take them from the humble coop to the top of the poultry world. In what's left of rural America, there is a poultry world. And it's bigger than you think. At a recent national competition, 12,000 birds showed up. They were not alone. Across the nation, 4-H kids and retirees, teachers and carpenters, lawyers and doctors, ministers and veterinarians exhibit poultry. Everyday people, quaint little hobby. But it makes a lot more sense once you look at the birds. Poultry fanciers have their reasons.

SOME DO IT FOR LOVE.

"The Silkies' disposition is just so phenomenal. They'll sit on anything resembling an egg. I swear, they'd sit on a golf ball...They're such tranquil birds. We've had them roost on the nose of our Great Dane. I give them to older people to put in a birdcage in the house; they're a terrific pet. We put 'em in baby strollers for parents to push around the fair, with the children. They put up with anything."—Mary Wagner

SOME DO IT FOR HONOR.

"I was kind of new to showing; it was 1986 and they had a show at Wisconsin State Fair Park and I just showed one chicken. My dad showed a few. I used to work nights and weekends, so we just dropped the birds off. And we came back the next day to see how my bird did, and it was gone. Well, it turns out it was on champion row."—Todd Kaehler

SOME SEE IT AS A SCIENTIFIC CHALLENGE.

"So many of your white birds are creamy. They're brassy. My bag is to genetically produce a white bird that stays white even in the elements, in the rain and the sun and all the conditions that go into tarnishing a white bird. I keep my birds a little longer to see who's going to go brass and who's going to stay white."—Ken Herring

SOME FEEL IT'S A WHOLESOME PURSUIT FOR A FAMILY.

"We have five children and they're all involved. The second year in a row that we had a champion at the Indiana State Fair, that was a high point. Our son won, then we turned around the next year and our daughter won."—Carolyn Krause

SOME WANT THE WHOLE WORLD TO BE DAZZLED BY THE BEAUTY OF CHICKENS.

"Every time you go to a show, you should wash the birds. I'll wash 'em this week, and if there's another show next week, I'll wash 'em again. They look so much better. I use four 5-gallon buckets. In my first, I use Ivory detergent with a little bluing. My second, I use vinegar and water. My third one, I use bluing and warm water. And my fourth, I use cool water and then pat them dry and put them in a cage with a light on them. The older chickens, they're so used to it, they sort of enjoy it." —Thola Waldau

Just in case you were wondering, nobody does it for the money.

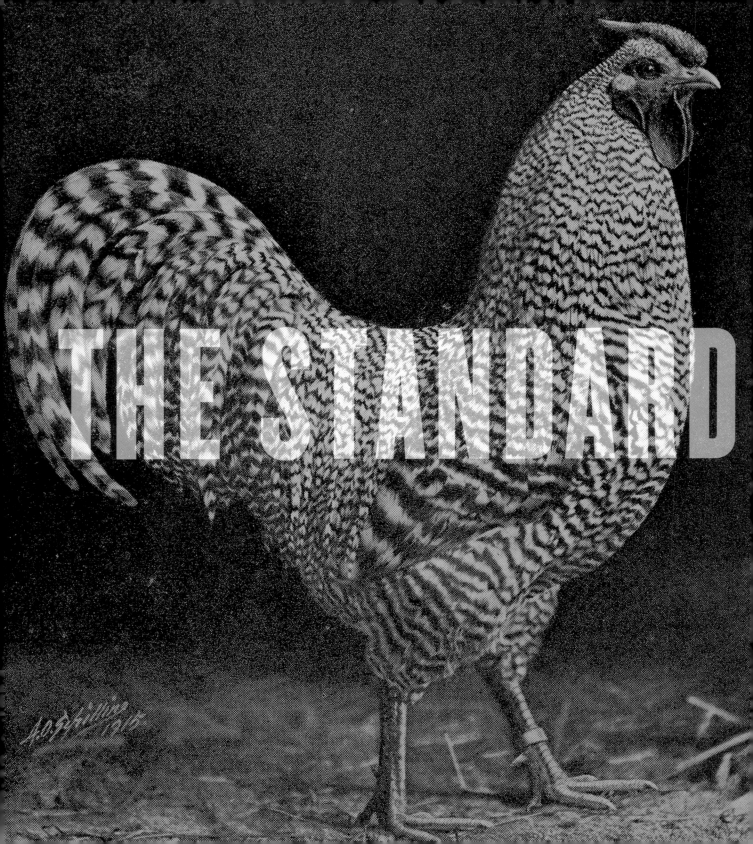

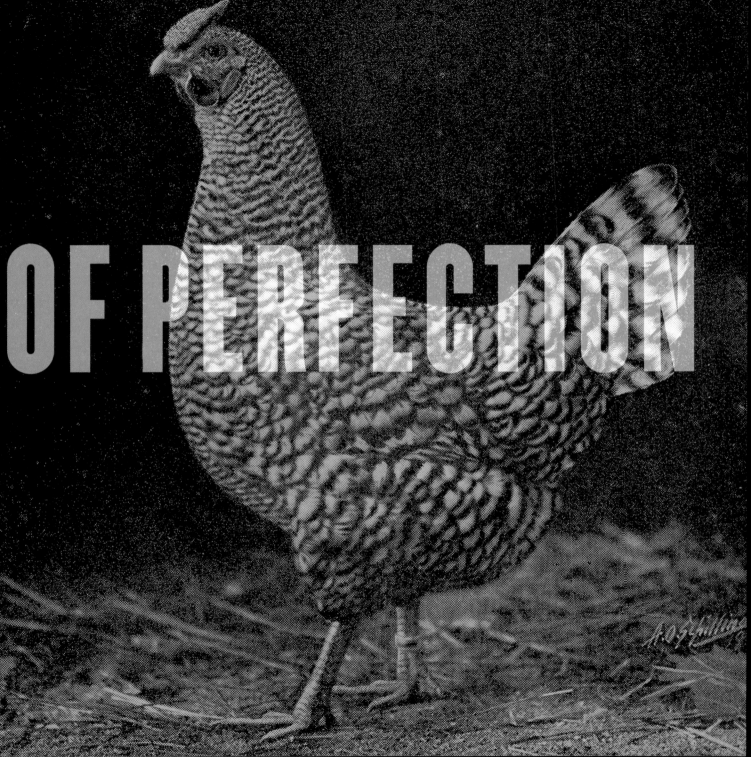

The Good Book

Shape. Size. Color. Feather quality. Weight. Combs and crests and feet and tails. In the world of champion chickens, there's a 100-point scale, and every feature counts. (And it helps if the chicken doesn't take a swipe at the judge.) Those looking for rhyme and reason in poultry fancy need merely open the *American Standard of Perfection*. Therein lie all the answers.

The *American Standard of Perfection* is regularly likened to the Bible. Almost every breeder or judge speaks of the book in such exalted terms. The *Standard* exhaustively discusses every possible nuance of a show chicken, and there is little to no ambiguity between its covers.

A poultry judge exercises a certain degree of latitude in scoring, for instance, feather condition—a leeway of three to four points on that hundred-point scale. But a number of automatic disqualifications apply to other traits. An example: toe count. Almost all chickens possess four toes on each foot. Only seven breeds regularly grow five toes instead, including Silkies. When a judge comes across a four-toed Silkie, the bird must be immediately disqualified, no matter how much loveliness all its other features demonstrate.

A book as exacting as the *Standard* requires the input of generations of very particular people. The first U.S. poultry exhibit took place in the Boston Gardens in November 1849. More than a thousand birds appeared in that initial show. Quickly, poultry fanciers acknowledged a burning need— for a standard by which breeders and judges could gauge a chicken's quality. The American Poultry Association was founded in 1873, and it promptly published the first *Standard of Perfection* in 1874. Subsequent editions include an expanded array of breeds and varieties,

but once included, descriptions are revised only after careful consideration of change proposals made by breed clubs and individuals. The *Standard* stays true to its convictions.

The American Standard of Perfection: A Complete Description of All Recognized Breeds and Varieties of Domestic Poultry makes no small claims. It is utterly comprehensive. The glossary defines terms such as *blade, dewlap, spike, spur, sprig,* and *sickle.* Relentless specificity is a given. Chicken earlobes are discussed at length: "…the fleshy patch of bare skin below the ears, varying in size, shape, and color according to the breed. The texture should always be fine and soft, the surface smooth, the outline regular and size uniform." The proper bearing for a bird is touched upon; *station* and *carriage* are terms used to describe ideal pose and symmetrical appearance. Definitions appear for *lopped, walnut, rose, pea, buttercup, cushion, Silkie, single, strawberry,* and *V-shaped* combs. Feather markings such as *ticking, tipping, striping, lacing, spangling,* and *mottling* are explained.

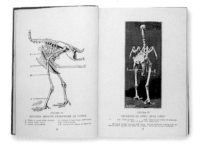

Side and rear views of chicken skeletal structure. 1930 edition.

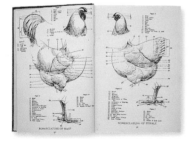

Examples of traits that differ between males and females. 1930 edition.

After the glossary, the *Standard* divides chickens into two major groups: bantams and large fowl. Bantams are diminutive fowl; a number are distinct breeds. Other bantams are miniatures of a large breed, approximately 20 to 25 percent of the weight of the corresponding large fowl. Among large fowl and bantams, eleven classes exist. Each class consists of anywhere from two to twenty-four related breeds. And most breeds have several varieties, generally based on color differences, represented in the *Standard*. Males and females exhibit some different characteristics, so each variety's listing is divided according to gender.

Illustrations and color plates, plus the text, fill more than three hundred pages of a hardcover volume about the size of a high school yearbook. And yet the judges carry the *Standard* with them as they go through the shows. No one can memorize it all, so judges frequently refer to the *Standard* to confirm requirements for a given variety. The book also comes in handy when someone needs a little lesson; a veteran judge regularly uses the *Standard* to explain to junior exhibitors what a particular chicken really should look like.

Poultry experts enjoy themselves while they take their role seriously. Judges rise from the ranks of breeders—they generally feel a passion for chickens. And American Poultry Association judges are required to pass rigorous written and showroom examinations. Only then do they put their skills to the test, lifting and examining bird after bird at show upon show. Judges hope that the fowl will cooperate and not get feisty. Otherwise, poultry fancy remains an orderly and rational thing, largely due to the structure created by the *American Standard of Perfection.*

The *Standard*'s word is final. But there is still something new at each year's cycle of shows. Because perfection is not a matter of coming close; perfection is absolute. And unattainable. Poultry fancy's veterans know the truth. They will never breed the perfect chicken. In a way, breeders take comfort in this fact. In the world of exhibition poultry, there is always another goal to reach, a better chicken to show.

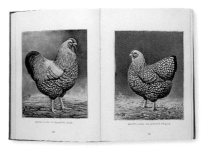

Plates showing a Silver-Laced Wyandotte male and female. 1930 edition.

Definitions and descriptions of important technical terms. 1930 edition.

A CLASS ACT: AMERICAN CHICKENS

LARGE AMERICAN CLASSES I–VI.

WINNERS AND LOSERS

Combs are conspicuous features that can make or break a chicken's championship run.

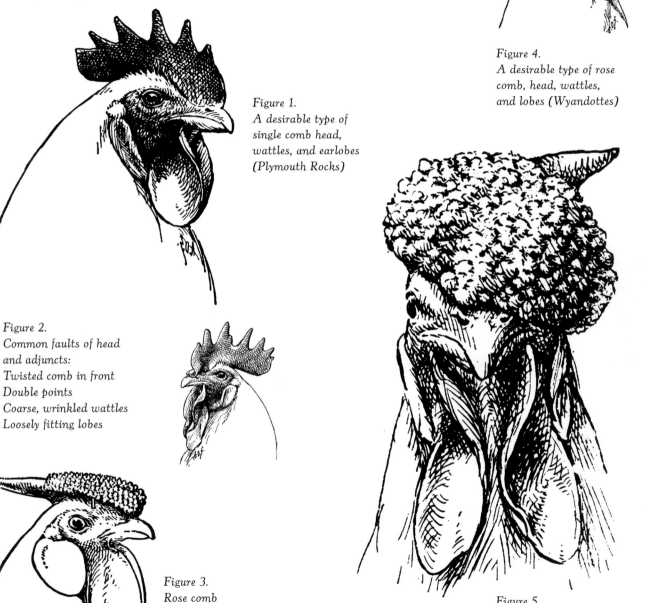

Figure 1.
A desirable type of single comb head, wattles, and earlobes (Plymouth Rocks)

Figure 4.
A desirable type of rose comb, head, wattles, and lobes (Wyandottes)

Figure 2.
Common faults of head and adjuncts:
Twisted comb in front
Double points
Coarse, wrinkled wattles
Loosely fitting lobes

Figure 3.
Rose comb
Base, rounded points, and spike

Figure 5.
Lopped rose comb
(a disqualification)

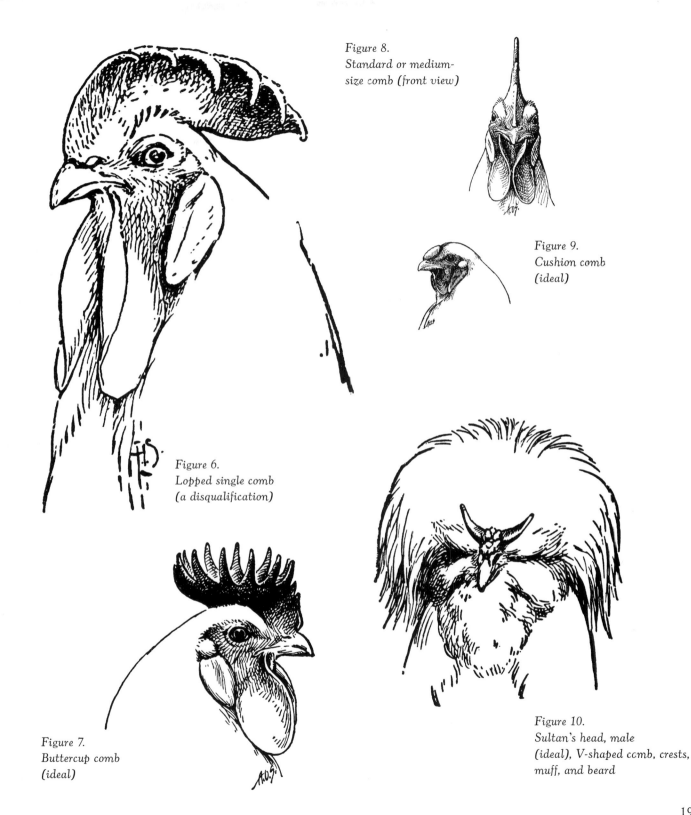

Figure 8.
Standard or medium-size comb (front view)

Figure 9.
Cushion comb
(ideal)

Figure 6.
Lopped single comb
(a disqualification)

Figure 10.
Sultan's head, male
(ideal), V-shaped comb, crests,
muff, and beard

Figure 7.
Buttercup comb
(ideal)

FINERY

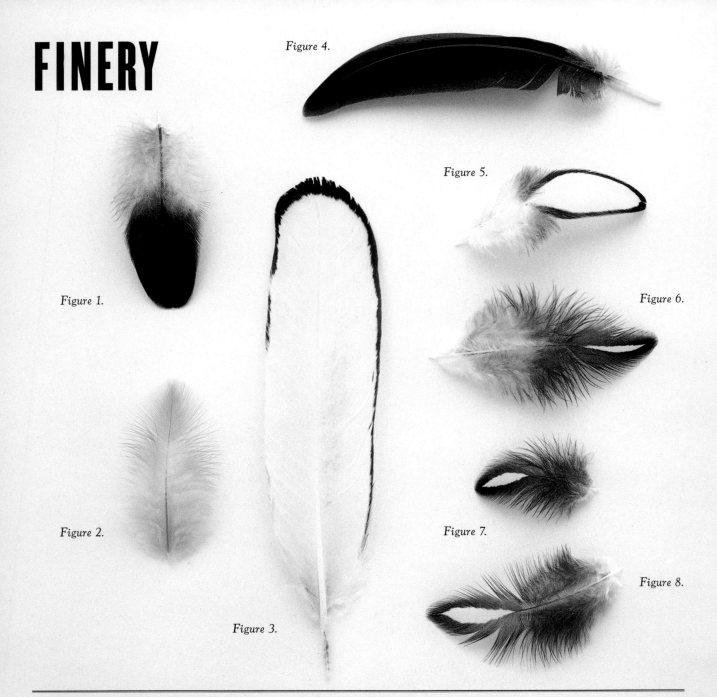

Figure 4.

Figure 5.

Figure 6.

Figure 1.

Figure 2.

Figure 3.

Figure 7.

Figure 8.

TYPICAL FEATHER SHAPES AND COLORING

Figure 1. Partridge Wyandotte male. Wing covert.
Figure 2. New Hampshire male. Tail covert.
Figure 3. Silver Sebright female. Secondary wing feather.
Figure 4. Partridge Wyandotte male. Primary wing feather.

Figure 5. Silver Sebright. Male breast feather.
Figure 6. Silver Sebright. Male neck feather.
Figure 7. Silver Sebright. Female neck feather.
Figure 8. Silver Sebright. Female stern feather.

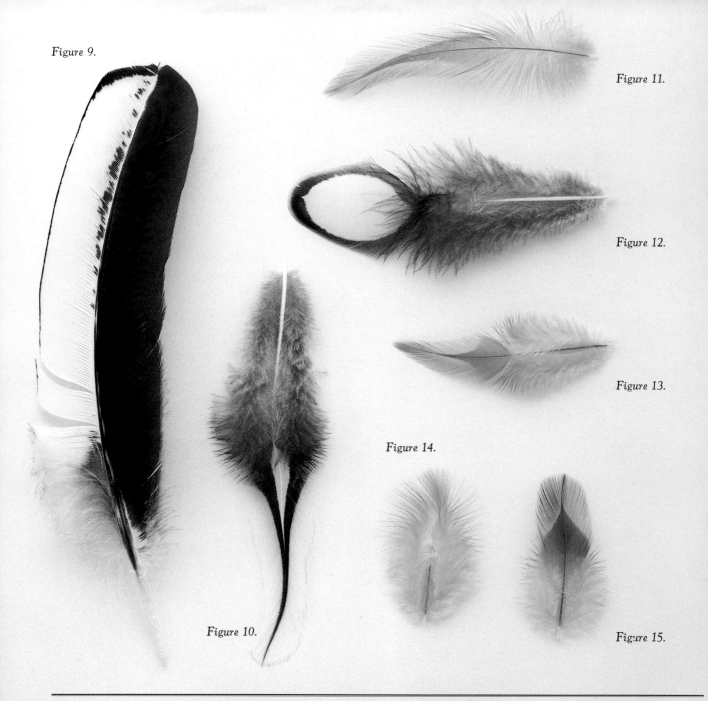

DIFFERENT TYPES OF STANDARD FEATHER PATTERNS

Figure 9. Silver Laced Wyandotte male.
Secondary wing feather.
Figure 10. Silver Laced Wyandotte male.
Upper saddle feather adjoining tail coverts.
Figure 11. New Hampshire male. Saddle feather.

Figure 12. Silver Laced Wyandotte female. Breast feather.
Figure 13. New Hampshire male. Hackle feather.
Figure 14. New Hampshire male. Stern feather.
Figure 15. New Hampshire female. Back feather.

ORIGIN India, where they are praised for their gameness.

FEATHER PATTERN
The face and throat are devoid of feathers. The tail is of medium length, carried below horizontal, and moderately spread.

COLORS Rich, glossy dark-red and greenish-black, with dark maroon on the back and undercolor of slate tinged with brown.

CLASS: ALL OTHER STANDARD BREEDS (ORIENTALS)

......................

Black Breasted Red Aseel Large Fowl Cockerel

Both males and females are possessed of an aggressive disposition, making them vigorous and tenacious survivors. The Aseel is a very old breed from India. It is quite strong, with well-developed muscles and a sprightly, upright carriage. An Aseel's compact body may look small but is really solid and heavy. The projecting brow brings an intense expression to the face, which is characteristic of the breed.

SHOWN Ohio National Poultry Show 1998
Columbus, Ohio

ADMITTED to the *Standard of Perfection* in 1981.

STANDARD WEIGHTS.

Cock5½ lb.
Cockerel4½ lb.
Hen4 lb.
Pullet3 lb.

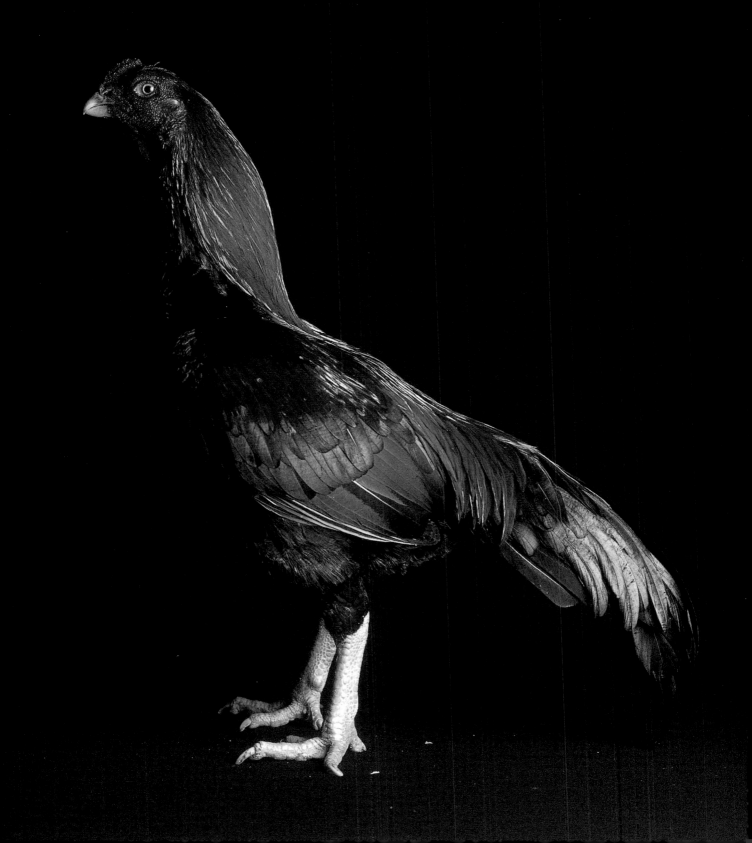

ORIGIN Developed gradually since about 1915 from a foundation of Rhode Island Reds, first brought into New Hampshire from Rhode Island and southern Massachusetts.

FEATHER PATTERN Broad, firm feather structure, overlapping well and fitting tightly to the body.

COLORS Medium, brilliant, and deep chestnut-reds, with a bay head and rich, lustrous greenish-black to black tail feathers.

CLASS: SINGLE COMB CLEAN LEGGED OTHER THAN GAME BANTAMS

New Hampshire Bantam Cockerel

Producing both eggs and meat, this bird occupies a role of importance in the poultry community. New Hampshires are known for early maturity, quick feathering, strength, and vigor. Their bodies are medium in length, broad, deep, and well-rounded. Their eyes are large, full, and prominent. A perfect New Hampshire comb is moderately large and absolutely straight, with five well-defined points. Expect stout, smooth shanks and moderately full fluff.

SHOWN Ohio National Poultry Show 1998 Columbus, Ohio

ADMITTED to the *Standard of Perfection* in 1960.

STANDARD WEIGHTS.

Cock 34 oz.
Cockerel 30 oz.
Hen 30 oz.
Pullet 26 oz.

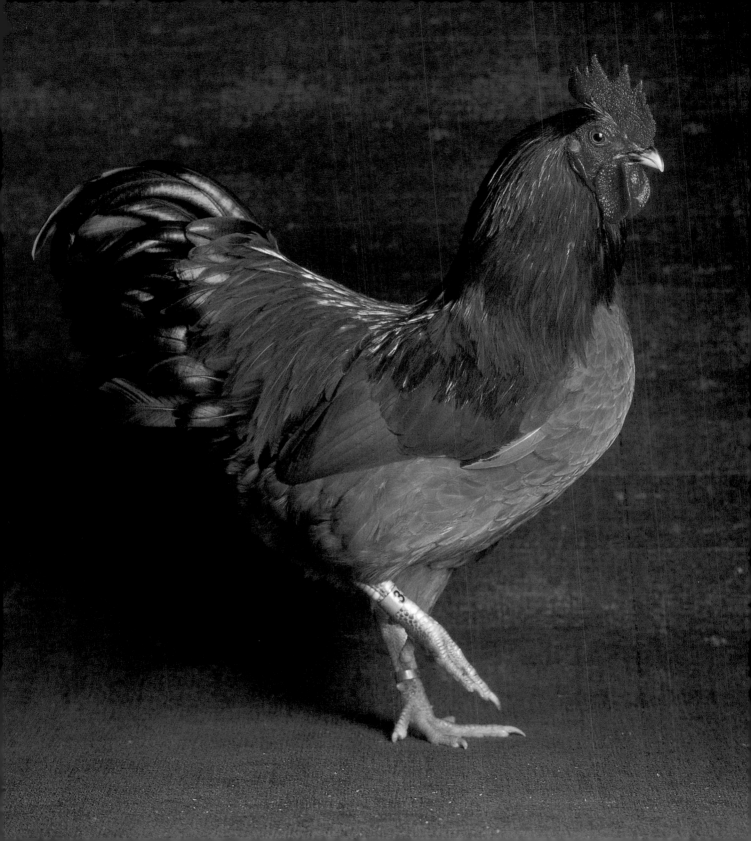

ORIGIN Part of the class of cocks used as fighters in the last several centuries in England.

FEATHER PATTERN Feathers broad and strong, tail well spread and carried at a 45-degree angle; hard, glossy, firm plumage overall.

COLORS Pale gold, orange red, pale straw, rich bay, dark gray, and white plumage. Bright-red face and comb, light horn beak, red eyes.

CLASS: ALL OTHER STANDARD BREEDS (OLD ENGLISH GAMES)

Old English Crele Bantam Cockerel

The Game fowl has from time immemorial stood as a symbol of courage and indomitable spirit. Game birds are now bred for exhibition and are a very competitive category at the poultry shows. Their faces are smooth, flexible, and finely textured. Their beaks are large, strong at the base, and well curved. Their combs are small, thin, erect, evenly serrated, and finely textured.

SHOWN Peach State Fanciers Poultry Show 1998 Commerce, Georgia

ADMITTED to the *Standard of Perfection* in 1996.

STANDARD WEIGHTS.

Cock24 oz.
Cockerel22 oz.
Hen22 oz.
Pullet20 oz.

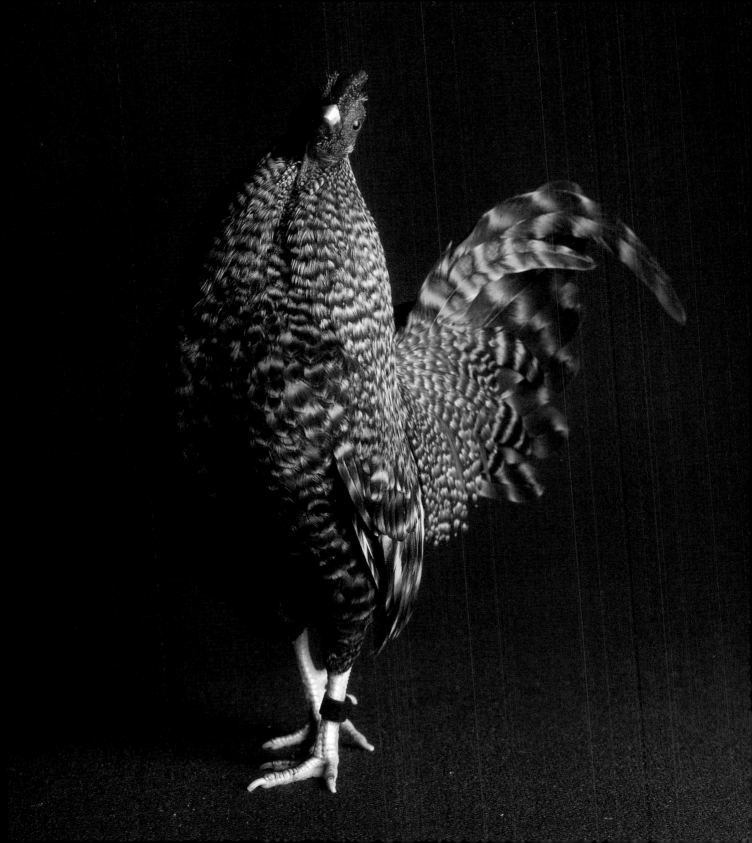

ORIGIN An ancient breed first noted in England and popular in the U.S. for quite a while now.

FEATHER PATTERN Hard, glossy, firm plumage, with plenty of color.

COLORS Red eyes, a neck of lustrous light-orange, red and orange wings with a breast of pure white, and beak, shank, and toes of pink-tinged white.

CLASS: ALL OTHER STANDARD BREEDS (OLD ENGLISH GAMES)

Old English Red Pyle Bantam Cockerel

As long as there have been cockfights, there were birds like these. Since cockfighting was suppressed in England in 1835 and poultry shows came into prominence a few years later, the bird that was known as the Pit Game started doing the show circuit and became known as the Old English Game. The Red Pyle variety is shown in large numbers and competition is vigorous. The breeder of the bird pictured here lamented the undesirable colored feathers mixed into the bird's white breast, but modestly admitted that the cockerel has good posture.

SHOWN Illini Poultry Show 1997
Belvidere, Illinois

ADMITTED to the *Standard of Perfection* in 1938.

STANDARD WEIGHTS.

Cock24 oz.
Cockerel22 oz.

Hen22 oz.
Pullet20 oz.

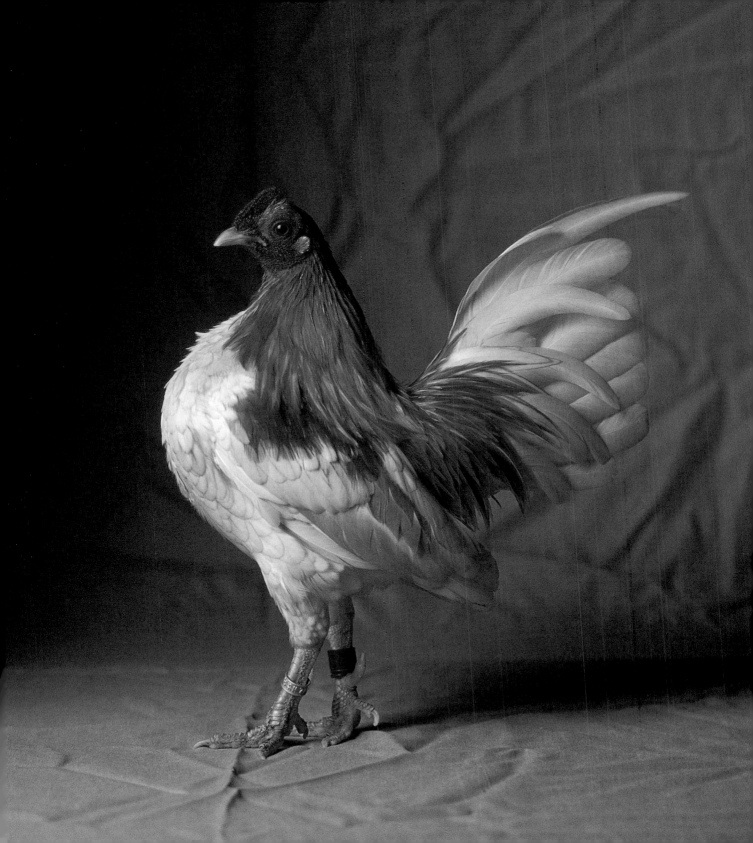

ORIGIN England. Have been in every U.S. *Standard* since the first was published in 1874.

FEATHER PATTERN Golden bay throughout, each feather evenly and distinctly laced with narrow edging of lustrous black.

COLORS Purplish-red face, same for earlobes (although turquoise is acceptable), bright-red wattles, slate-blue shanks and toes. Golden-bay plumage and slate undercolor.

CLASS: ROSE COMB CLEAN LEGGED BANTAMS

························

Golden Sebright Bantam Cockerel

A place in history goes to this bird. Sir John Sebright intensively bred for thirty years to create his feathered namesakes, who were the first specialty chickens to have a club for their enthusiasts. Sir John's efforts paid off with a breed boasting remarkable feathers: no Sebright males have any typical male pointed or sickle feathers.

PHOTOGRAPHED in Merton, Wisconsin, at the Verres house.

ADMITTED to the *Standard of Perfection* in 1874.

STANDARD WEIGHTS.

Cock22 oz.
Cockerel20 oz.

Hen20 oz.
Pullet18 oz.

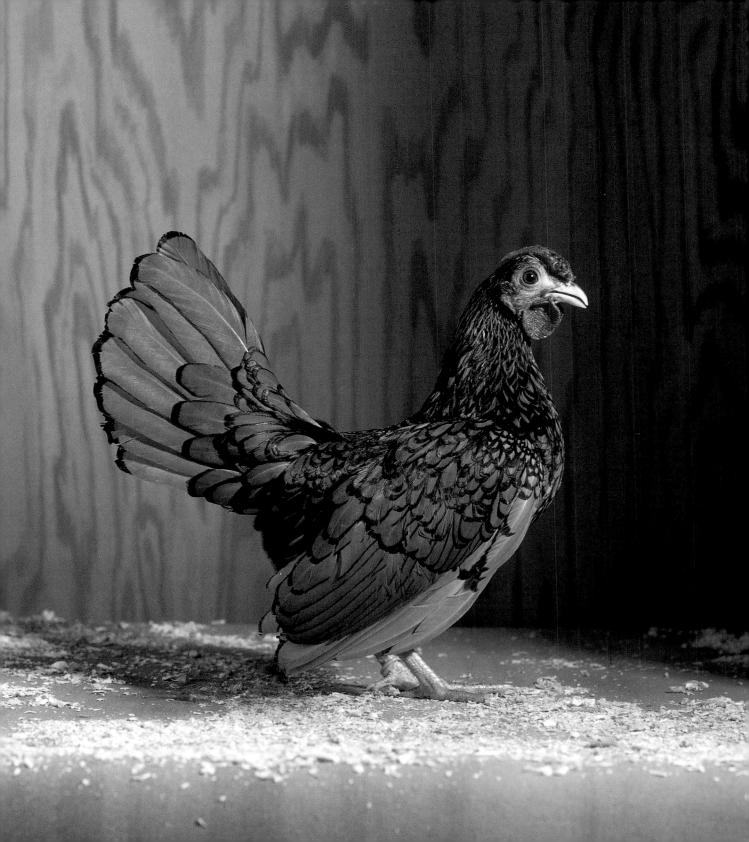

ORIGIN Cornwall, England. The first variety was the Dark Cornish, and the others sprang from it.

FEATHER PATTERN
One of the distinctions of the breed, body plumage should be close fitting, the feathers short, hard, and quite narrow, the well-knit webs giving brilliancy to the color pigments.

COLORS Rich, dark red on the body and breast, each feather regularly laced with a narrow racing of white. Comb, face, wattles, and earlobes are bright-red, beak is yellow, eyes are pearl.

CLASS: ENGLISH

·····

White Laced Red Cornish Large Fowl Cock

White Laced Red Cornish were produced in the United States in 1898 from a Shamo Japanese/ Dark Cornish cross. Note this model's sturdy yellow shanks and toes, typical of the breed. In all respects, this is a meaty bird, and its uses reflect this reality; Cornish are super-heavy meat-producing fowl, also valued for crossing with other breeds for the production of market poultry.

SHOWN Ohio National Poultry Show 1998
Columbus, Ohio

ADMITTED to the *Standard of Perfection* in 1909.

STANDARD WEIGHTS.

Cock10½ lb.
Cockerel8½ lb.
Hen8 lb.
Pullet6½ lb.

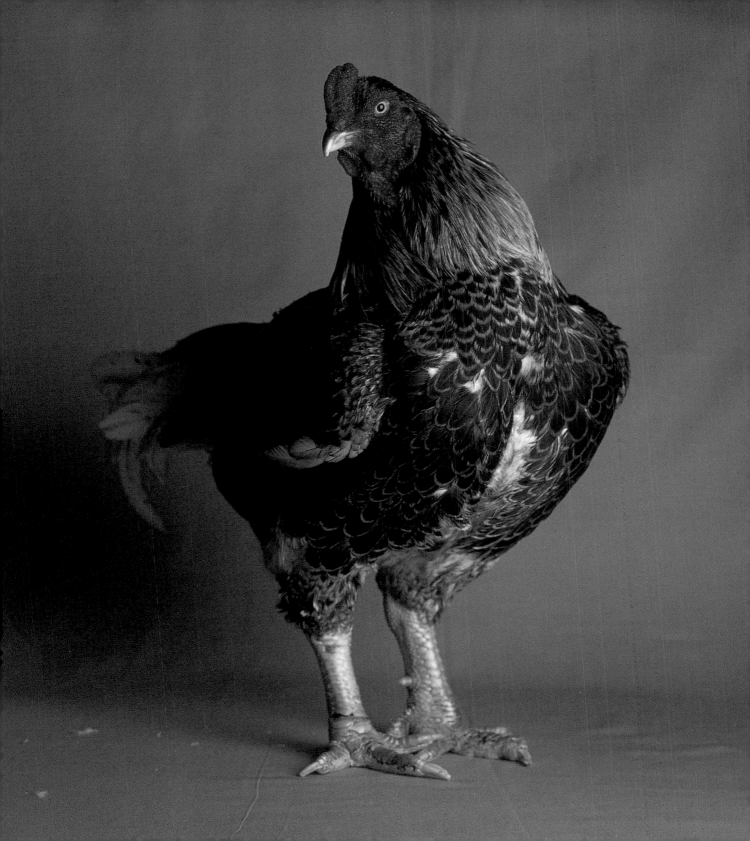

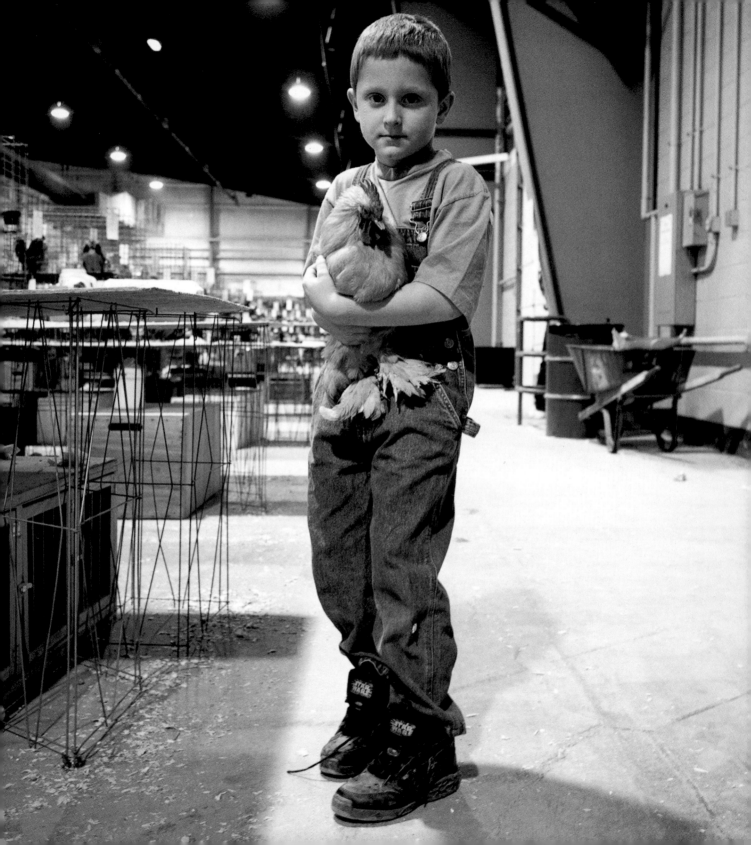

Though not a chicken, it's a bird—
that's good enough for this breeder.

Two young competitors keep company
with a charming and easy-going silkie.

Some of the largest poultry shows
have several thousand birds competing.

The best show chickens remain
tranquil under heavy scrutiny.

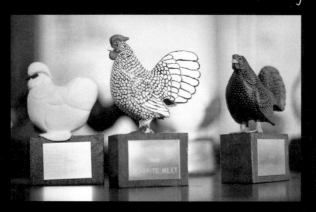

Some winners receive handsome
trophies, handcrafted by George Cairns.

Breeders express genuine admiration
of winning birds—even someone else's.

ORIGIN The English imported these birds from Eastern Europe and dubbed them Poland Fowls.

FEATHER PATTERN The distinguishing characteristic is the crest of feathers growing atop the knot on the Polish fowl's skull.

COLORS Lustrous, golden buff laced with creamy white and a creamy white undercolor on the body. Slate blue beak, reddish-bay eyes, bright red comb, and a main tail of golden buff.

CLASS: CONTINENTAL (POLISH)

Bearded Buff Laced Polish Large Fowl Cock

This is the definitive ornamental fowl, not bred for meat or eggs. It's highly prized for exhibition, with its crowning glory a large protuberance atop its head, from which springs a crest of striking feathers. This poultry royalty has been established as a pure breed since the early sixteenth century. Its sophisticated European flair adds glamour to American poultry fancy.

SHOWN Indiana State Fair 1998 Indianapolis, Indiana

ADMITTED to the *Standard of Perfection* in 1898.

STANDARD WEIGHTS.

Cock 6 lb.
Cockerel 5 lb.
Hen 4½ lb.
Pullet 4 lb.

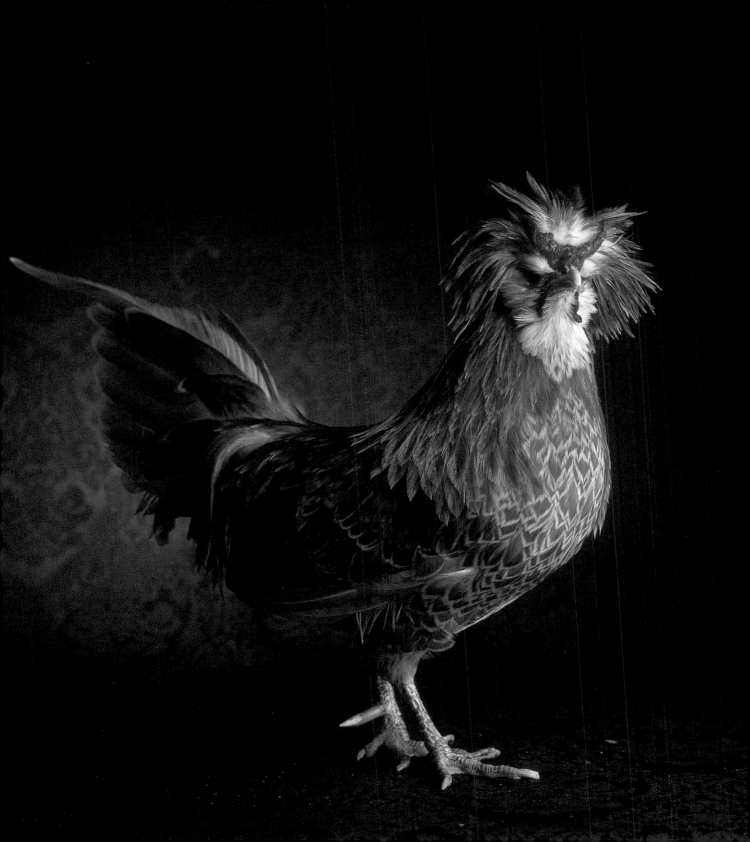

ORIGIN Booted and d'Uccle bantams came to this country in the Mille Fleur variety from Germany but were also very popular in Belgium and England.

FEATHER PATTERN Extreme foot feathering and a widely spread tail carried at a jaunty, high angle are important defining characteristics. Thick beard and muffs.

COLORS Straw head feathers with small white spangles. Narrow bar of pale blue. Beard and muff golden-buff and black tipped with white.

CLASS: FEATHER LEGGED BANTAMS

Belgian Mille Fleur Bearded d'Uccle Bantam Cock

Each feather in the Mille Fleur coloration is required to provide visual interest with its intricate patterning. The upper neck has a mane-like appearance. The bird's body is rather short and compact, while the wings are proportionally large and the breast is carried well forward. The elaborate foot feathering is something that breeders take great pains to maintain so the bird shows to best advantage.

SHOWN Illini Poultry Show 1998
Belvidere, Illinois

ADMITTED to the *Standard of Perfection* in 1914.

STANDARD WEIGHTS.

Cock26 oz.
Cockerel22 oz.

Hen22 oz.
Pullet20 oz.

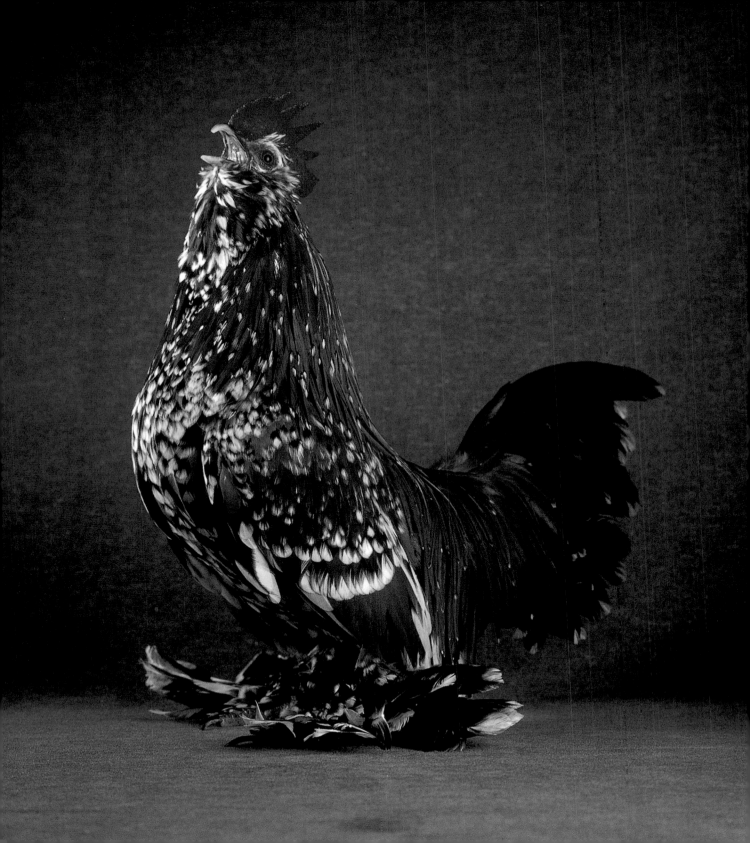

ORIGIN The Pit Game cocks that fought for an audience of the fashionable set in Great Britain.

FEATHER PATTERN Shortness and hardness of feathers are key.

COLORS The black breast contrasts with a bright-red back and a light golden saddle. The tail is black and lustrous. The head's plumage is light orange, the neck light golden.

CLASS: ALL OTHER STANDARD BREEDS (GAMES)

Black Breasted Red Modern Game Bantam Cock

This bird has ascended to its current heights thanks to the ideals of exhibition game fanciers, who created this unique chicken just as fighting cocks fell out of style. Modern Game birds are now used strictly for show. This bird is supposed to stand tall and proud. The long, lean, bony head is thought to express a certain aristocratic quality.

SHOWN Illini Poultry Show 1997
Belvidere, Illinois

ADMITTED to the *Standard of Perfection* in 1874.

STANDARD WEIGHTS.

Cock22 oz.
Cockerel20 oz.
Hen20 oz.
Pullet18 oz.

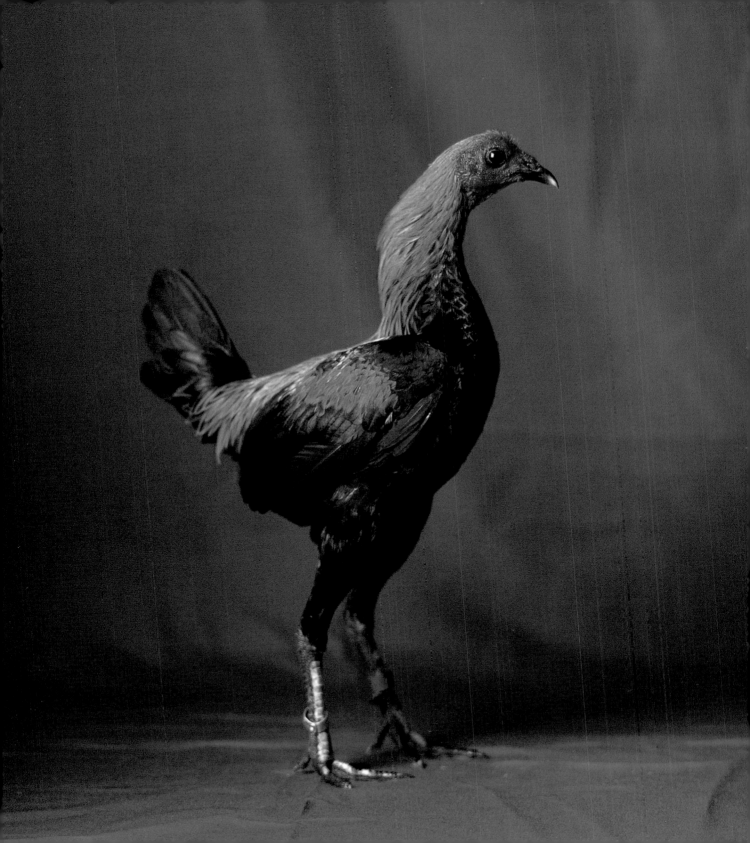

ORIGIN Early nineteenth-century England.

FEATHER PATTERN Distinctly laced with glossy black.

COLORS The variety's name derives from the comb, which is rose. The head is a glossy black. Back, saddle, wings, and tail are an even shade of clear, bluish slate, with lacing of black.

CLASS: ROSE COMB CLEAN LEGGED BANTAMS

......................................

Blue Rose Comb Bantam Cockerel

Rose combs in general enjoy an enduring popularity. They're appreciated for their proud and stylish bearing as well as their quality of feather, their lustrous colors, and their perfection of comb and lobe. They're familiar on the show circuit; some variety has been included in every *Standard of Perfection* since the first, in 1874. The Blue Rose Comb is a somewhat more recent addition to poultry fancy.

SHOWN Ohio National Poultry Show 1998 Columbus, Ohio

ADMITTED to the *Standard of Perfection* in 1960.

STANDARD WEIGHTS.

Cock 26 oz.
Cockerel 22 oz.
Hen 22 oz.
Pullet 20 oz.

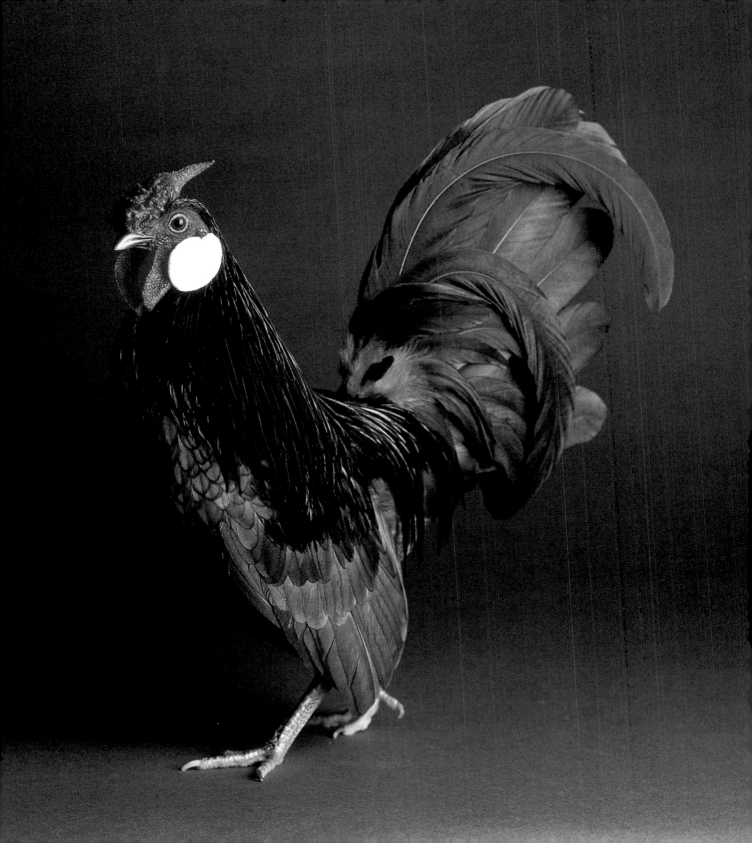

ORIGIN In Belgium, where they have been bred for several centuries.

FEATHER PATTERN Close-fitting plumage. Lustrous, greenish-black barred straight across with golden bay.

COLORS Lustrous greenish-black, golden bay, white plumage on the head, beak of horn and dark brown eyes, with a jaunty bright-red comb. Toes are leaden blue.

CLASS: CONTINENTAL (NORTH EUROPEAN)

Golden Campine
Large Fowl Cock

Primarily bred for egg production, the Campines attract attention at exhibitions thanks to their sprightly carriage and attractive color markings. Campines are heftier than they look because their feathers fit so close, so they're required to reach somewhat surprising weights to be considered good examples of their variety.

SHOWN Illini Poultry Show 1997 Belvidere, Illinois

ADMITTED to the *Standard of Perfection* in 1914.

STANDARD WEIGHTS.

Cock6 lb.
Cockerel5 lb.
Hen4 lb.
Pullet3½ lb.

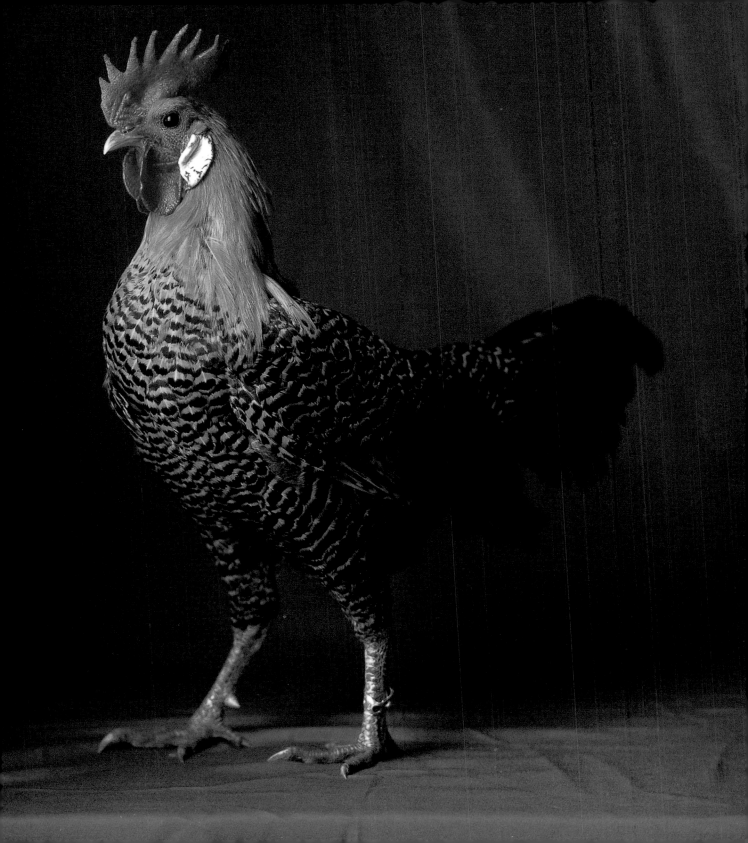

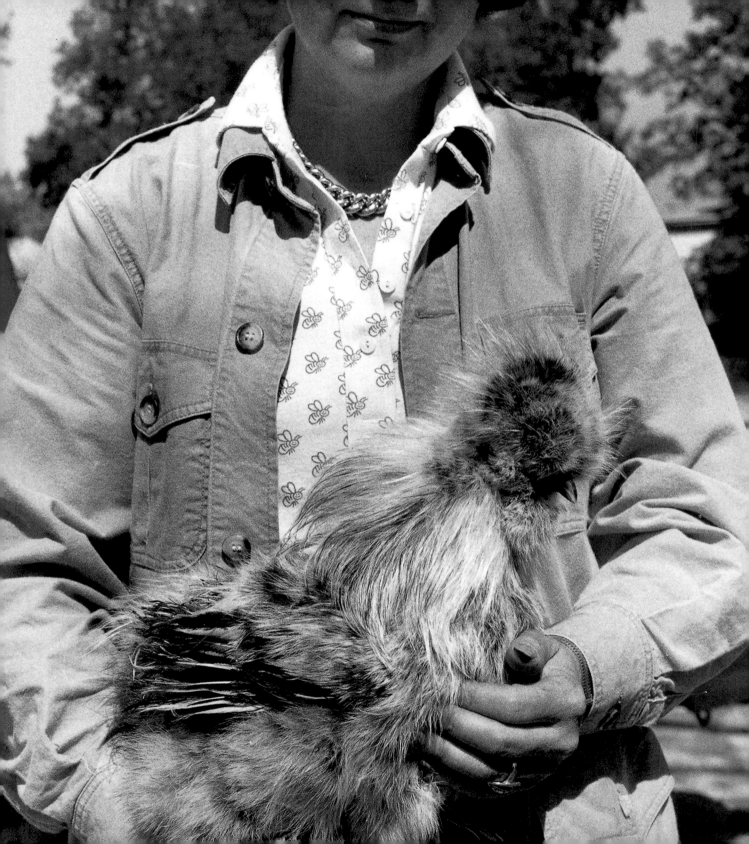

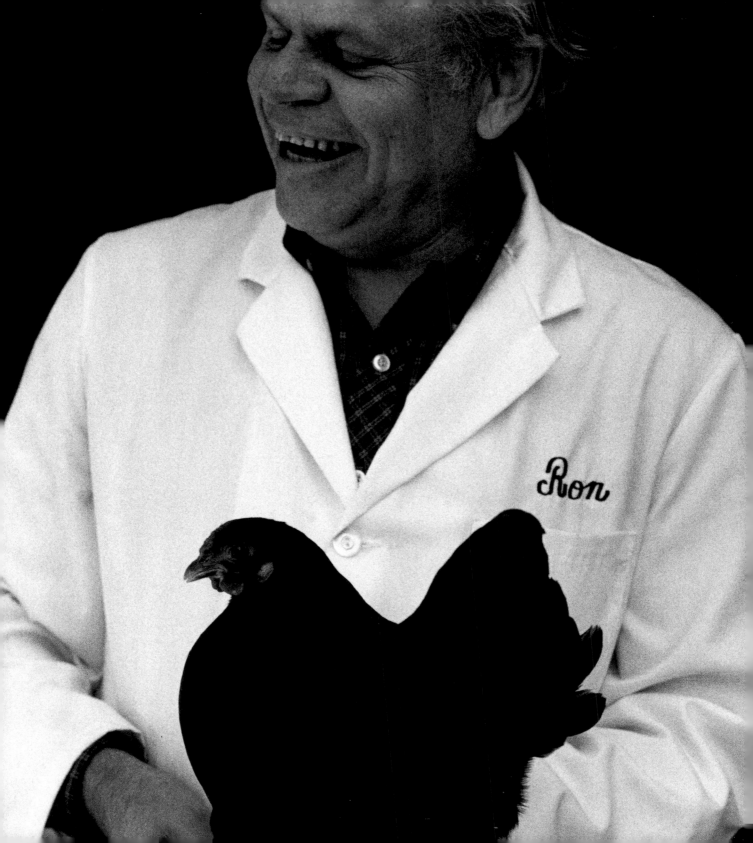

ORIGIN China; they were first known as Pekins and in England are still called by this name.

FEATHER PATTERN
Profuse feathering that is blue throughout; red, yellow, orange, or white in the plumage is an automatic disqualification.

COLORS Bright-red face, beak yellow shaded with black, feet and toes of yellow, and otherwise blue, blue, blue.

CLASS: FEATHER LEGGED BANTAMS

Blue Cochin Bantam Cock

Cochin Bantams have long been a favorite in North America. The *Standard* of 1874 lists four different Cochin Bantam varieties. Fanciers favor the Cochin's profuse feathering and enjoy keeping company with a bird of such gentle disposition. The *Standard* demands monochromatic uniformity in feather colors.

SHOWN Indiana State Fair 1998
Indianapolis, Indiana

ADMITTED to the *Standard of Perfection* in 1977.

STANDARD WEIGHTS.

Cock32 oz. Hen28 oz.
Cockerel28 oz. Pullet26 oz.

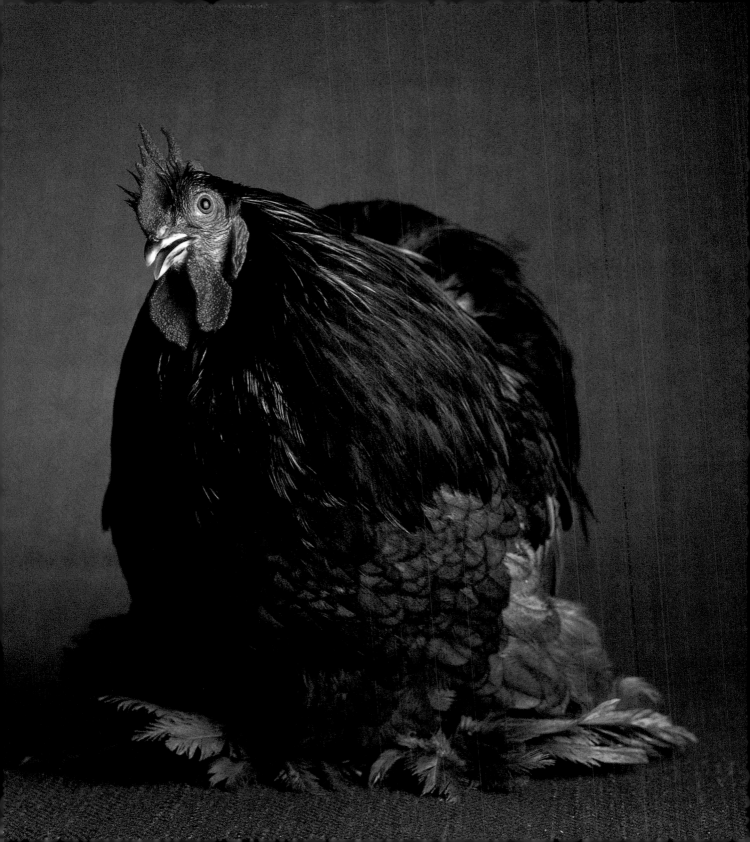

ORIGIN France, with many of these birds once populating the town of Houdan.

FEATHER PATTERN Lustrous, greenish-black feathers, with one of every two or three tipped in white, depending on the part of the body.

COLORS Black plumage, bright-red comb, face, and wattles, dark horn beak, crest and beard of black and white, shanks and toes of pinkish white, mottled with black.

CLASS: ALL OTHER COMBS CLEAN LEGGED BANTAMS

Mottled Houdan Bantam Pullet

The Houdan's extravagant feathering is its most conspicuous feature. A few other Houdan fine points: a long, compact, well-proportioned body with a full, well-rounded breast, and five toes per foot rather than the four found on most other varieties. Poultry show judges scrupulously count the number of toes.

SHOWN Illini Poultry Show 1998 Belvidere, Illinois

ADMITTED to the *Standard of Perfection* in 1960.

STANDARD WEIGHTS.

Cock 34 oz.
Cockerel 30 oz.

Hen 30 oz.
Pullet 26 oz.

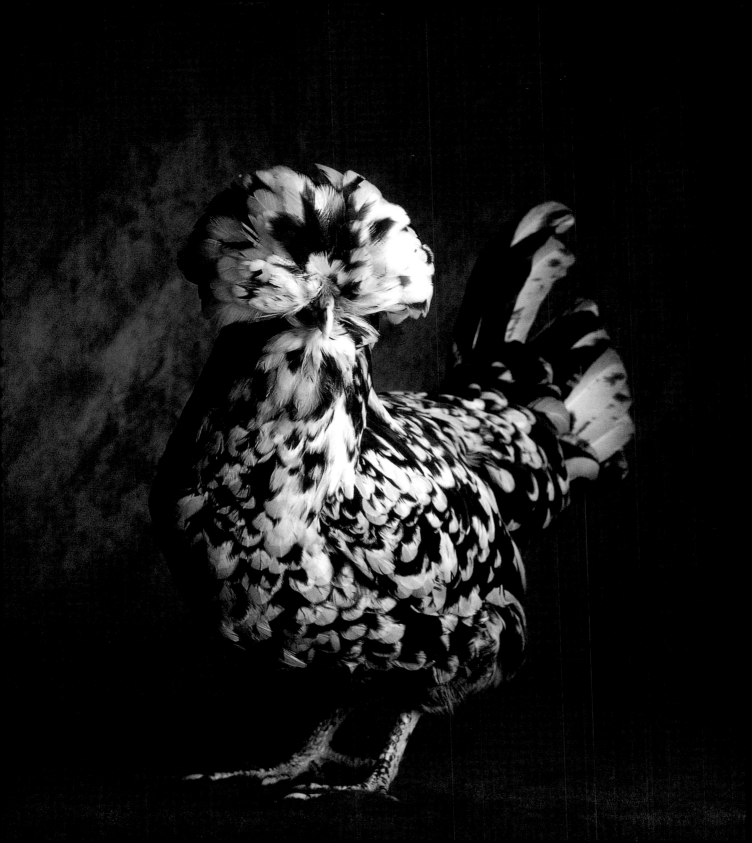

ORIGIN Probably descended from the many hawk or gray fowls kept in New England before any poultry standards existed.

FEATHER PATTERN Feathers are crossed by irregular dark and light bars, excellence to be determined by distinct contrasts.

COLORS Slate plumage barred with colors just short of positive black and white, bright-red comb, face, wattles, and earlobes, yellow beak, reddish-bay eyes, yellow shanks and toes.

CLASS: AMERICAN

Dominique
Large Fowl Cock

Everything about this bird should be big — solid and substantial. The rose comb sits firm and straight on the head. The eyes are large, full, and prominent. The wattles are broad. The tail is long. The breast is wide, round, and held high. The Dominique's commercial value is great: these fowl are useful for both meat and egg production.

SHOWN Ohio National Poultry Show 1998 Columbus, Ohio

ADMITTED to the *Standard of Perfection* in 1874.

STANDARD WEIGHTS.

Cock7 lb.
Cockerel6 lb.
Hen5 lb.
Pullet4 lb.

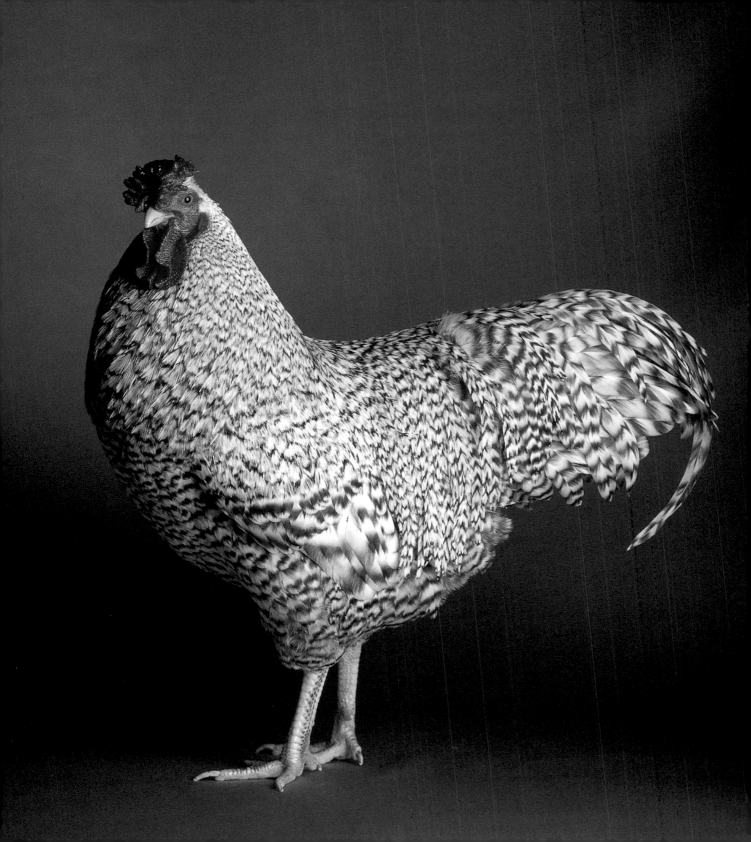

ORIGIN From Germany, but quite popular in Belgium and England.

FEATHER PATTERN Diamond-shaped spangles tipping golden bay feathers.

COLORS Golden bay, reddish brown, and creamy white plumage, light slate undercoat. Bright-red comb and face, reddish-bay eyes, light horn beak, light slate shanks and toes.

CLASS: FEATHER LEGGED BANTAMS

Golden Neck Belgian Bearded d'Uccle Bantam Cock

On top, this breed flaunts a thick, full beard and muff. At its other extremity, it shows dramatic foot feathering. This latter trait requires careful maintenance and great care on the part of the breeder, and a quiet life for the show bird, who can't risk breaking his feathers. These chickens often live in nice, soft bedding as a result.

SHOWN Peach State Fanciers Poultry Show 1998 Commerce, Georgia

ADMITTED to the *Standard of Perfection* in 1996.

STANDARD WEIGHTS.

Cock26 oz.
Cockerel22 oz.

Hen22 oz.
Pullet20 oz.

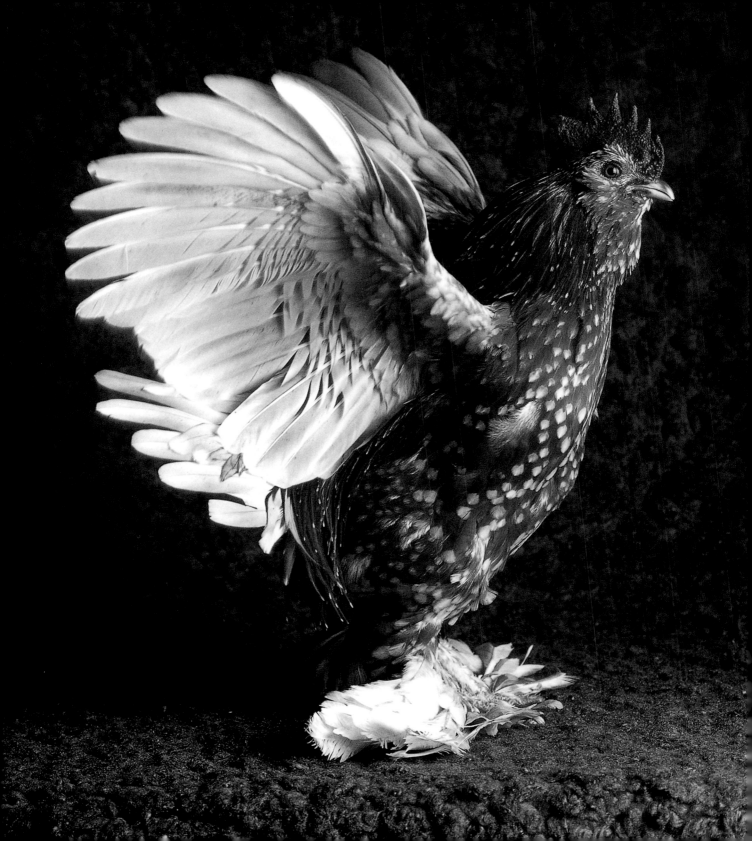

ORIGIN England. Have been in every U.S. *Standard* since the first was published in 1874.

FEATHER PATTERN Silvery white throughout, each feather evenly and distinctly laced with narrow edging of lustrous black.

COLORS Purplish-red face, same for earlobes (although turquoise is acceptable), bright-red wattles, slate blue shanks and toes. Silvery-white plumage and slate undercolor.

CLASS: ROSE COMB CLEAN LEGGED BANTAMS

Silver Sebright Bantam Cock

A handsome fowl and one of historical significance — the Sebright Bantam Club was the first specialty poultry club, founded in 1815 by Sir John Sebright in England. Sir John's work represents a great achievement of fancier skill with marvelous lacing patterns on the feather. Even more noteworthy is the fact that certain pointed male feathers — in the mane, hackle, saddle, wing-bow, and sickle of the tail — simply do not occur in male Sebrights.

SHOWN Peach State Fanciers Poultry Show 1998 Commerce, Georgia

ADMITTED to the *Standard of Perfection* in 1874.

STANDARD WEIGHTS.

Cock22 oz.
Cockerel20 oz.
Hen20 oz.
Pullet18 oz.

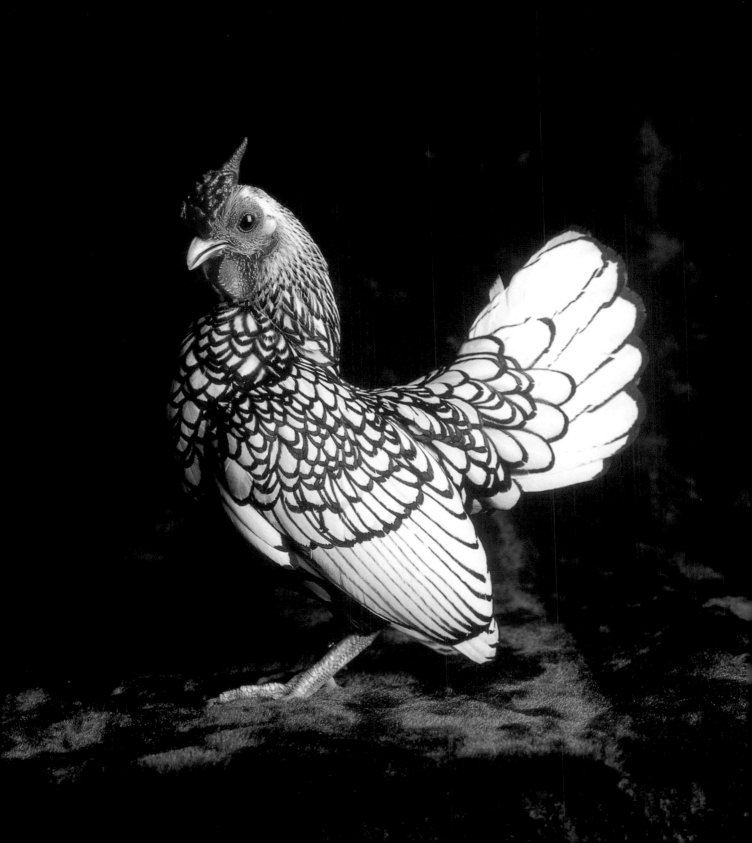

ORIGIN Cornwall, England, though known as Indian Game outside the U.S.

FEATHER PATTERN Close-fitting, short, hard, narrow feathers are a strong characteristic. Firmly webbed feathers make the colors brilliant.

COLORS Lustrous, greenish-black plumage with dark slate under-color. Pearl eyes, set in bright-red faces; also bright-red comb and wattles. Yellow beak and rich, yellow legs and toes.

CLASS: ENGLISH

Dark Cornish
Large Fowl Cock

One of the biggest breeds of chickens, the Cornish contributes to the poultry world on a large scale. Cornish fowl are valued for crossing with other breeds, since their genes encourage the production of large amounts of meat. The significance of the Cornish is reflected in its popularity on the exhibition scene.

SHOWN Peach State Fanciers Poultry Show 1998 Commerce, Georgia

ADMITTED to the *Standard of Perfection* in 1893.

STANDARD WEIGHTS.

Cock10½ lb.
Cockerel8½ lb.
Hen8 lb.
Pullet6½ lb.

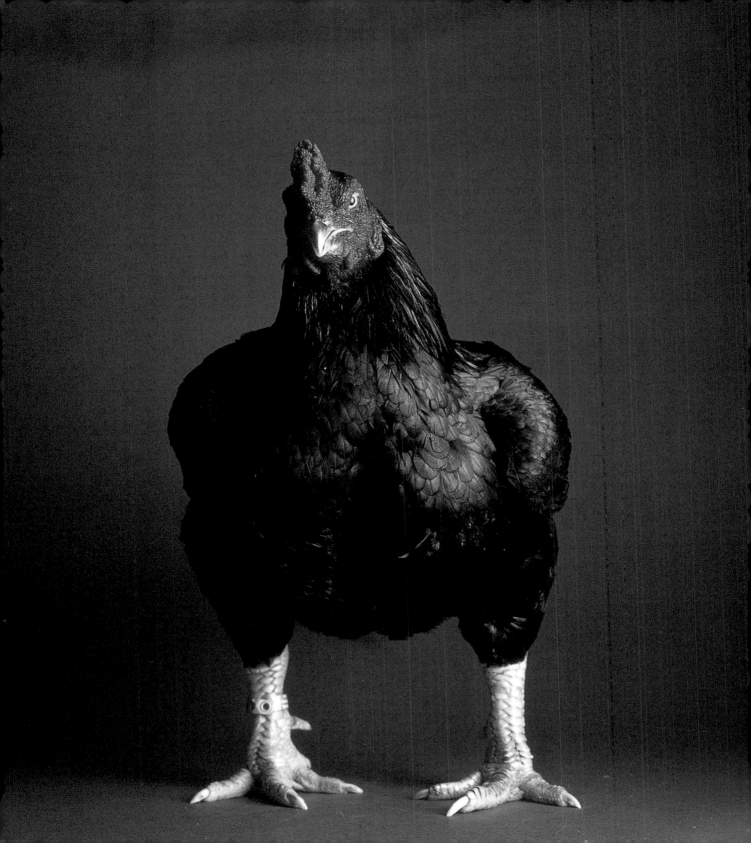

ILLINI SHOW HOSTING MEETS

A. P. A. - Club Meet

A. B. A. - Special Meet

Cochin Int'l - Regional Meet

Am. Brown Leghorn - District Meet

Int'l Waterfowl - District Meet

Am. White Leghorn - State Meet

Int'l Cornish Breeders - State Meet

New Hampshire Breeders - State Meet

Am. Australorp Breeders - State Meet

Old English Game Bantam - State Meet

Ameraucana Breeders - State Meet

No. Am. Hamburg - State Meet

Silver Wyandotte - State Meet

Am. Silkie Bantam - Club Meet

Old English Lg. Fowl - Challenge Meet

Faverolles Fanciers - Breed Meet

Modern Game Breeders - Special Meet

Sebright Club of Am. - Special Meet

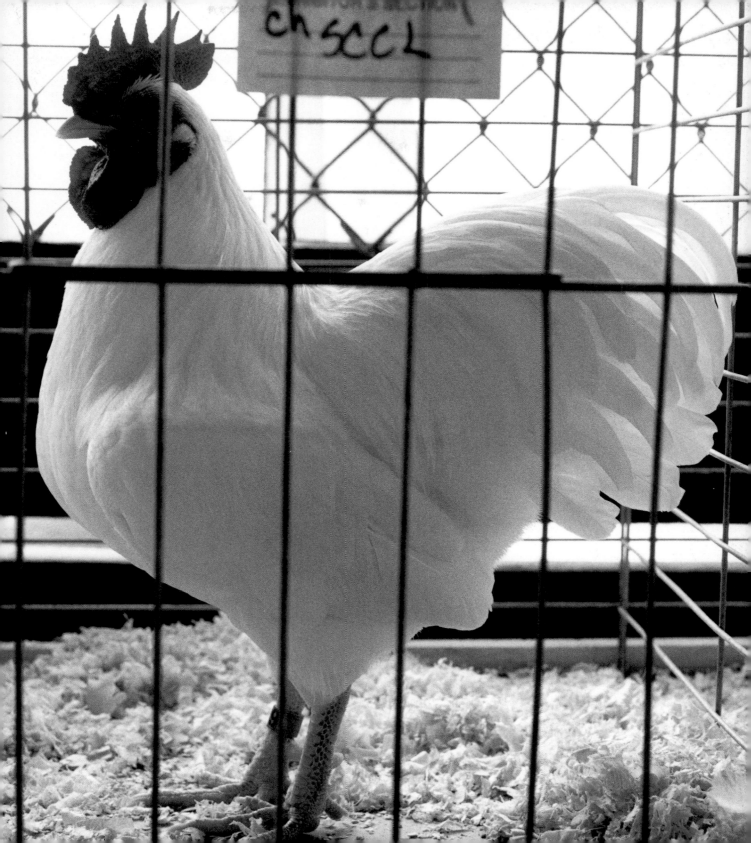

CLASS: SINGLE COMB CLEAN LEGGED (OTHER THAN GAME) BANTAMS

..

Silver Dutch Bantam Cock

A straight neck is considered a defect for Dutches; this bird's neck curves gracefully. Another fault is a tail carried low, but this one is carried upright and proud. Exhibitors encourage these birds to stand tall, with chest thrust out. A welcome recent addition to the *Standard*, the Dutch Bantam is thought of as a very attractive newcomer.

ORIGIN The Netherlands, like the Holland Bantams in this class.

FEATHER PATTERN Interesting neck hackle feathers have a dull black stripe that becomes intense and brilliant as it moves down the feather.

COLORS Plumage alternates silvery-white and black. Comb, face, and wattles bright-red. Pure white earlobes. Reddish-bay eyes, bluish horn beak, slate blue toes.

SHOWN Ohio National Poultry Show 1998 Columbus, Ohio

ADMITTED to the *Standard of Perfection* in 1992.

STANDARD WEIGHTS.

Cock21 oz. Hen20 oz.
Cockerel19 oz. Pullet18 oz.

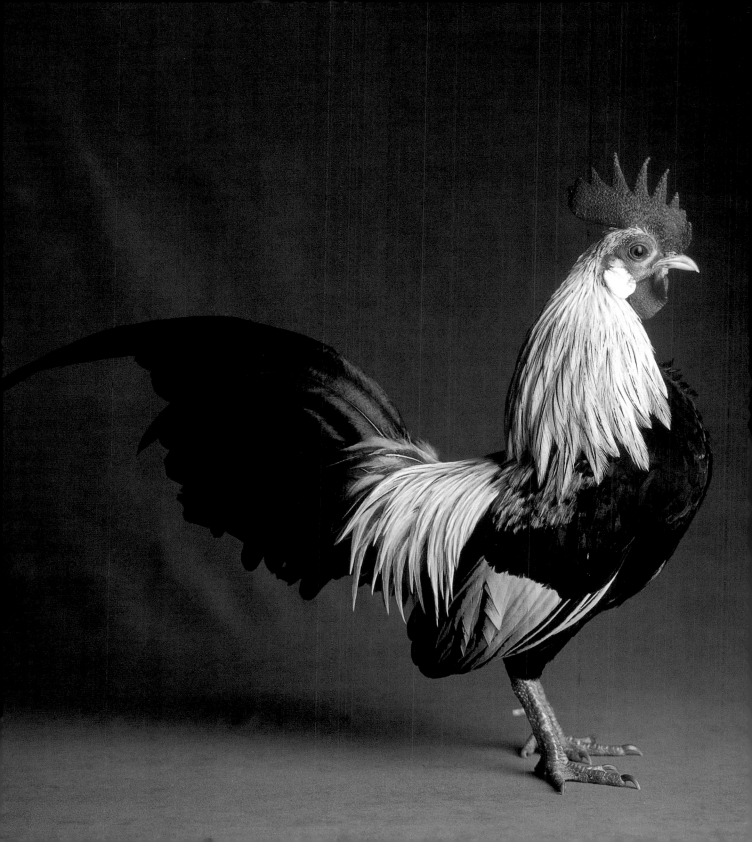

ORIGIN New York State, along with the other Wyandottes.

FEATHER PATTERN Narrow lacing or shafting of red on many of the black feathers.

COLORS Bright-red comb and face, dark horn beak with yellow point. Lustrous, rich red, greenish-black, reddish bay plumage, slate undercolor.

CLASS: ROSE COMB CLEAN LEGGED BANTAMS

Partridge Wyandotte Bantam Cock

The Wyandotte breed derives from an intricate background, and the Partridge variety is typical. It is a cross of the Partridge Cochin, the Golden Wyandotte, and in some parts of the country but not all, the Cornish. Note the size: this is one of the bigger members of the bantam class.

SHOWN Ohio National Poultry Show 1998 Columbus, Ohio

ADMITTED to the *Standard of Perfection* in 1933.

STANDARD WEIGHTS.

Cock30 oz.
Cockerel26 oz.

Hen26 oz.
Pullet24 oz.

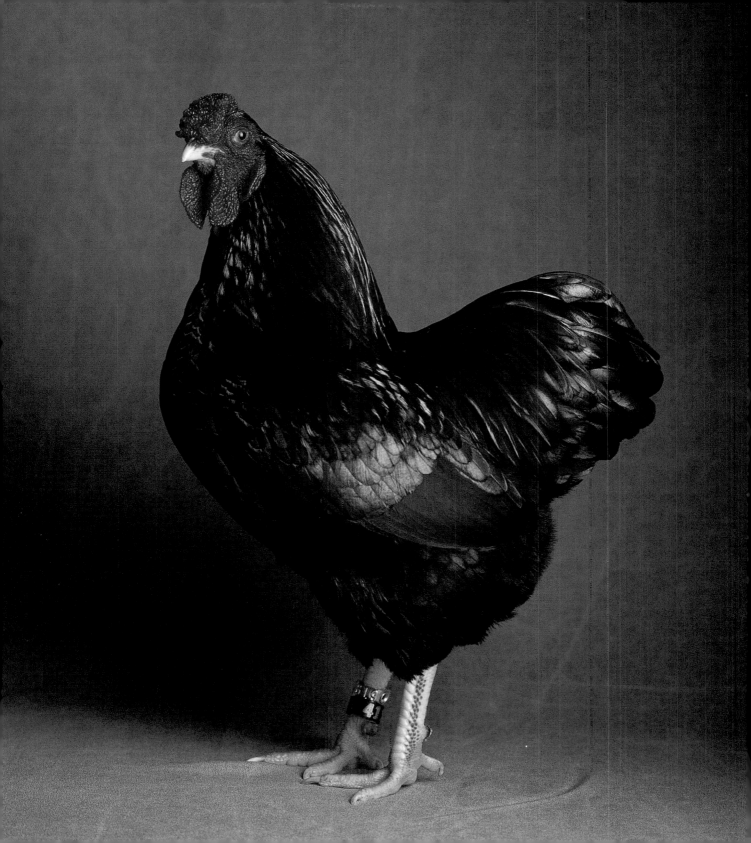

ORIGIN From somewhere in South America, first imported to the U.S. in the 1930s.

FEATHER PATTERN Silvery-white and blue-black with distinct bars in a few sections of the body.

COLORS Silvery-white plumage with blue-black. Beard is black shading to salmon. Willow shanks and toes.

CLASS: ALL OTHER COMBS CLEAN LEGGED BANTAMS

Silver Duckwing Araucana Bantam Cock

What is unusual for most chickens is typical of the Araucana. Its hens lay a distinctive turquoise- or blue-shelled egg. It is missing a rump. Tufts of feathers spring out from either side of the neck. Araucana breeders cultivate these traits, and judges expect them.

SHOWN Blackhawk Poultry Show 1998 Janesville, Wisconsin

ADMITTED to the *Standard of Perfection* in 1976.

STANDARD WEIGHTS.

Cock 22 oz.
Cockerel 20 oz.
Hen 20 oz.
Pullet 18 oz.

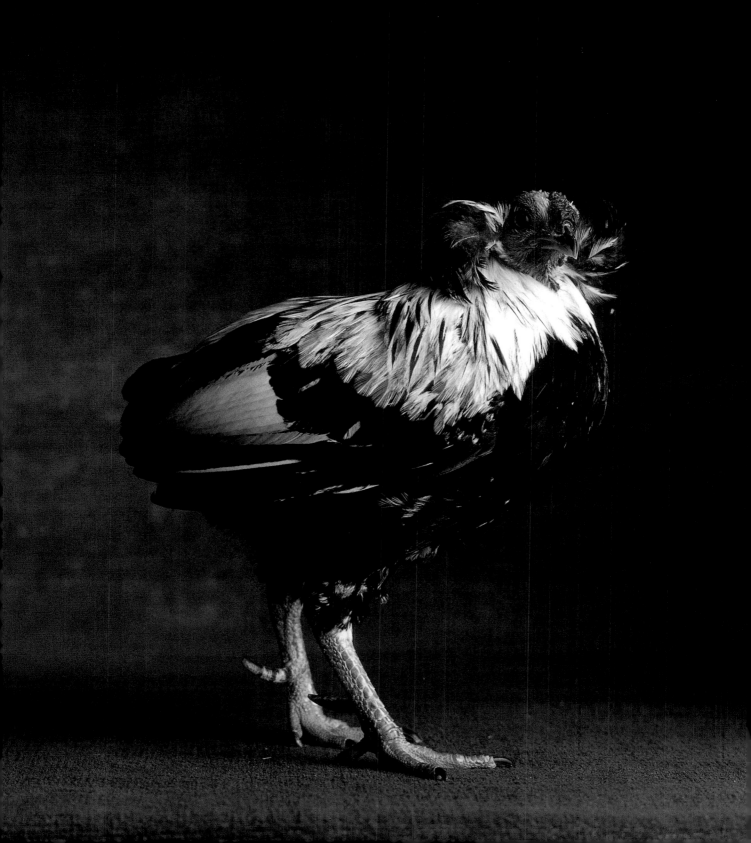

ORIGIN Massachusetts, where variations were first shown in 1849 and 1869.

FEATHER PATTERN Each feather is crossed with sharp parallel bars of light and dark color.

COLORS Plumage with alternating bars just short of white, just short of black. Red face and comb, yellow beak, reddish eyes, yellow shanks and toes.

CLASS: AMERICAN

Barred Plymouth Rock Large Fowl Cockerel

At the first U.S. poultry show, visitors saw the Plymouth Rock breed. This is an established and valued bird. The Barred variety's feathers are noteworthy: the bars (crosswise stripes) on feathers all around the body make the bird instantly recognizable.

SHOWN Blackhawk Poultry Show 1995 Janesville, Wisconsin

ADMITTED to the *Standard of Perfection* in 1874.

STANDARD WEIGHTS.

Cock9½ lb. Hen7½ lb.
Cockerel8 lb. Pullet6 lb.

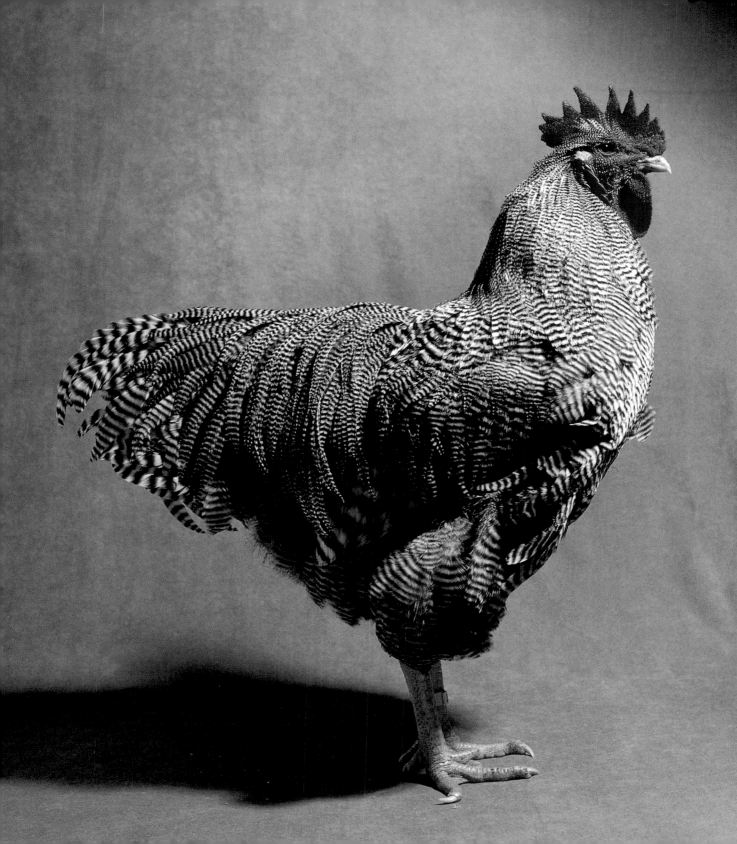

CLASS: ROSE COMB CLEAN LEGGED BANTAMS

......................................

Quail Belgian Bearded d'Anvers Bantam Cockerel

Long enjoying popularity in Europe and England, these birds are gaining more notice here in the U.S. Their distinct and jaunty bearing and unique colors afford them a special place in poultry fancy. The quail color shown here is the only such hue in the *Standard*.

ORIGIN Definitely Europe, likely but not proven to be Belgium.

FEATHER PATTERN Slight lacing on neck and feathers, shafts on some body, tail, and wing feathers.

COLORS Plumage is black, golden bay, straw, brownish yellow, and grayish yellow. Bright-red comb, face, and wattles, dark brown eyes, slate blue toes.

SHOWN Blackhawk Poultry Show 1998 Janesville, Wisconsin

ADMITTED to the *Standard of Perfection* in 1949.

STANDARD WEIGHTS.

Cock 26 oz.
Cockerel 22 oz.
Hen 22 oz.
Pullet 20 oz.

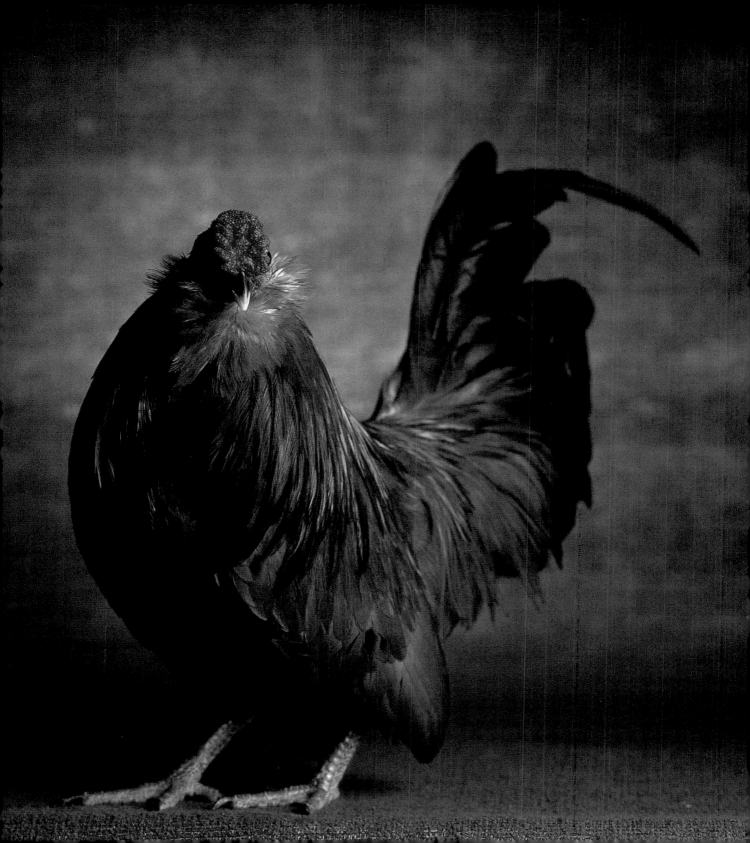

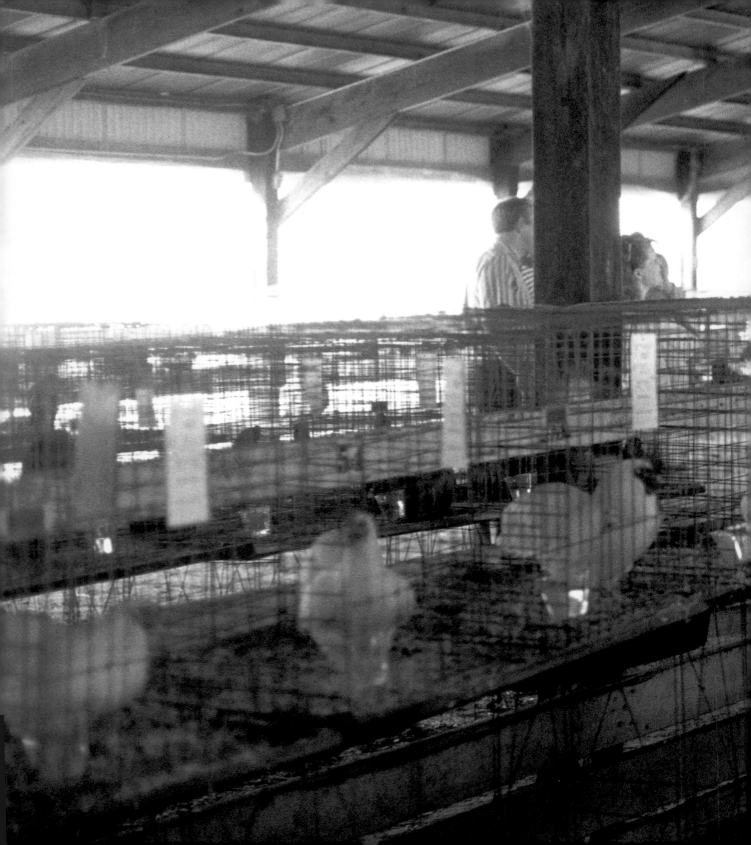

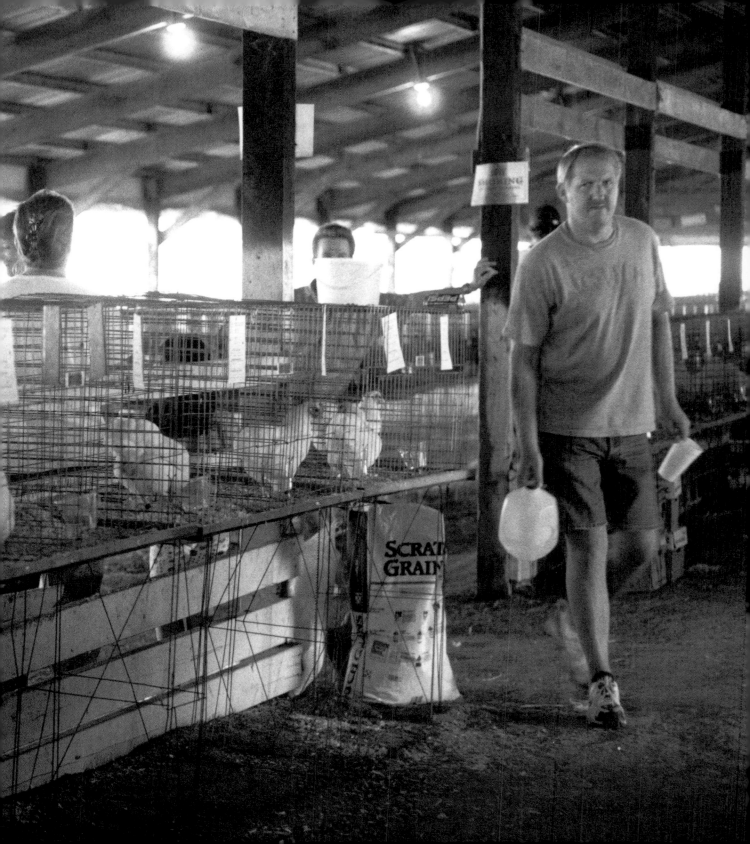

ORIGIN New York State, where all Wyandottes were developed.

FEATHER PATTERN Narrow lacing or shafting of red on many of the black feathers.

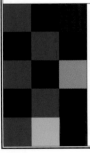

COLORS Bright-red comb and face, yellow beak. Reddish-bay eyes. Lustrous greenish-black plumage, slate undercolor.

CLASS: ROSE COMB CLEAN LEGGED BANTAMS

Black Wyandotte Bantam Cock

Once known as the American Sebright or Sebright Cochin, the Wyandotte is shown in many varieties. Its long, rounded, fine wattles are noticeable and considered a highlight. The straight legs and deep breast make a strong impression. Because of its long heritage and solid qualities, it is thought of as a great American bird.

SHOWN Peach State Fanciers Poultry Show 1998 Commerce, Georgia

ADMITTED to the *Standard of Perfection* in 1933.

STANDARD WEIGHTS.

Cock30 oz.
Cockerel26 oz.
Hen26 oz.
Pullet24 oz.

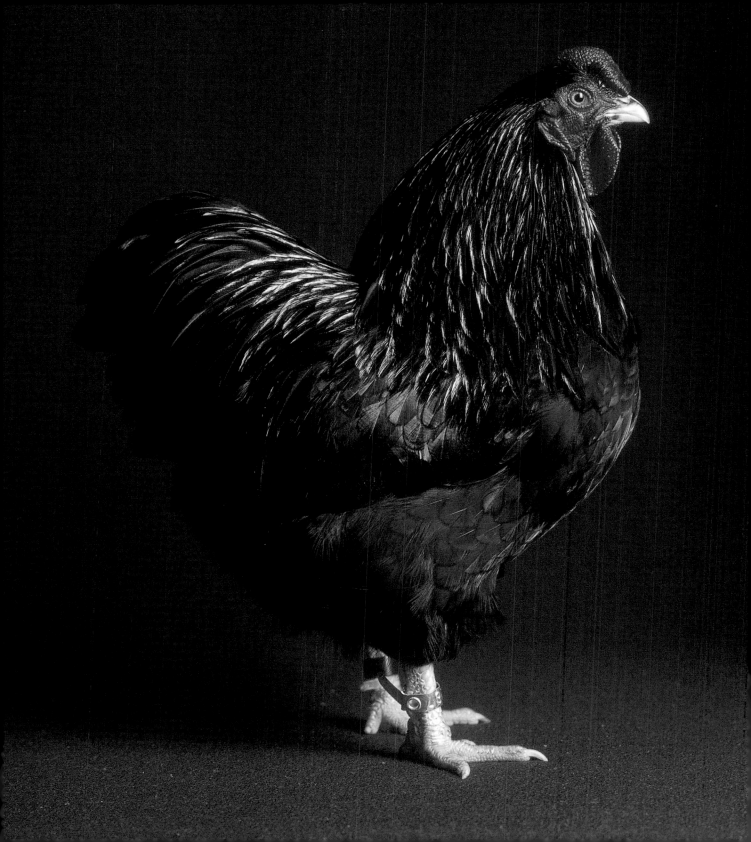

ORIGIN Some experts say Silkies originated in Japan, some say China; Marco Polo described similar birds in his writings about the Far East.

FEATHER PATTERN
The fluffy plumage results from feather barbs going in various directions instead of webbing into a normal feather pattern.

COLORS Deep mulberry comb, face, and wattles. Leaden blue beak. Eyes are black. Turquoise earlobes. Web, fluff, and shafts of all feathers are lustrous greenish-black.

CLASS: FEATHER LEGGED BANTAMS

Bearded Black Silkie Bantam Hen

Silkie bantams are one of the oddities of the poultry world. Their hairlike plumage is absolutely unique. They also have nearly black skin, face, comb, wattles, bones, and meat. The Silkies' temperament is as soft as their appearance; they are pleasant, low-key, gentle, and rather sedentary.

SHOWN Indiana State Fair 1998
Indianapolis, Indiana

ADMITTED to the *Standard of Perfection* in 1965.

STANDARD WEIGHTS.

Cock	36 oz.
Cockerel	26 oz.
Hen	26 oz.
Pullet	24 oz.

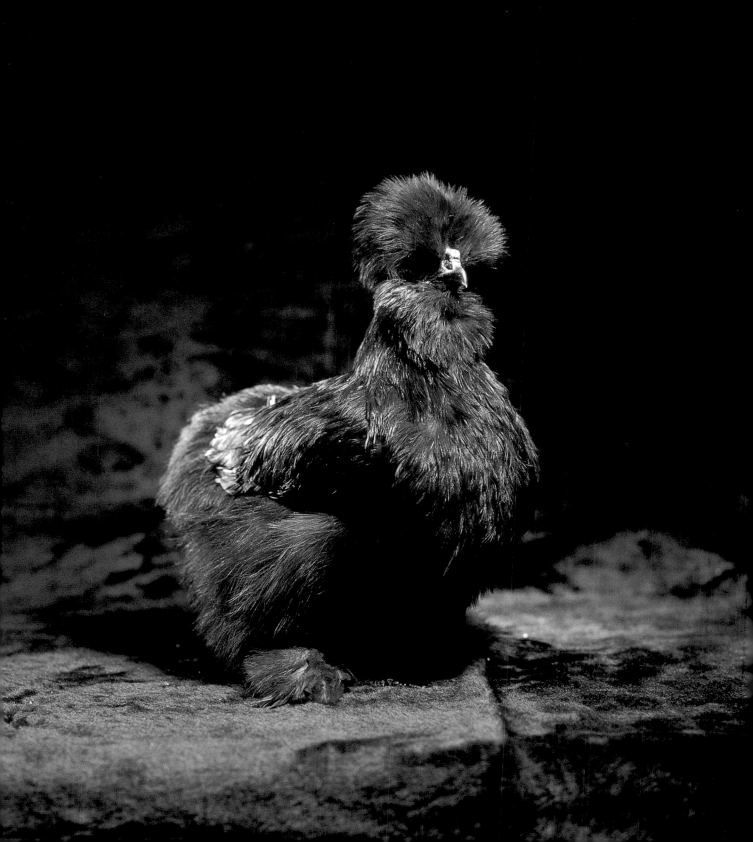

ORIGIN From Germany, after attaining popularity in Belgium and England.

FEATHER PATTERN Some feathers are barred, others striped, yet others have diamond-shaped spangles.

COLORS Pale blue, straw, and pure white plumage. Very pale blue undercolor with a tint of straw at the base. Fluff is pale blue tipped with white. The shanks and toes are also blue.

CLASS: FEATHER LEGGED BANTAMS

Porcelain Belgian Bearded d'Uccle Bantam Cockerel

The delicate and elegant porcelain feather coloration demands the special care of meticulous exhibitors. The breeder of this bird uses an elaborate bathing regimen before each show to bring out the subtle pastels and patterns in the plumage.

SHOWN Ohio National Poultry Show 1998 Columbus, Ohio

ADMITTED to the *Standard of Perfection* in 1965.

STANDARD WEIGHTS.

Cock26 oz.
Cockerel22 oz.
Hen22 oz.
Pullet20 oz.

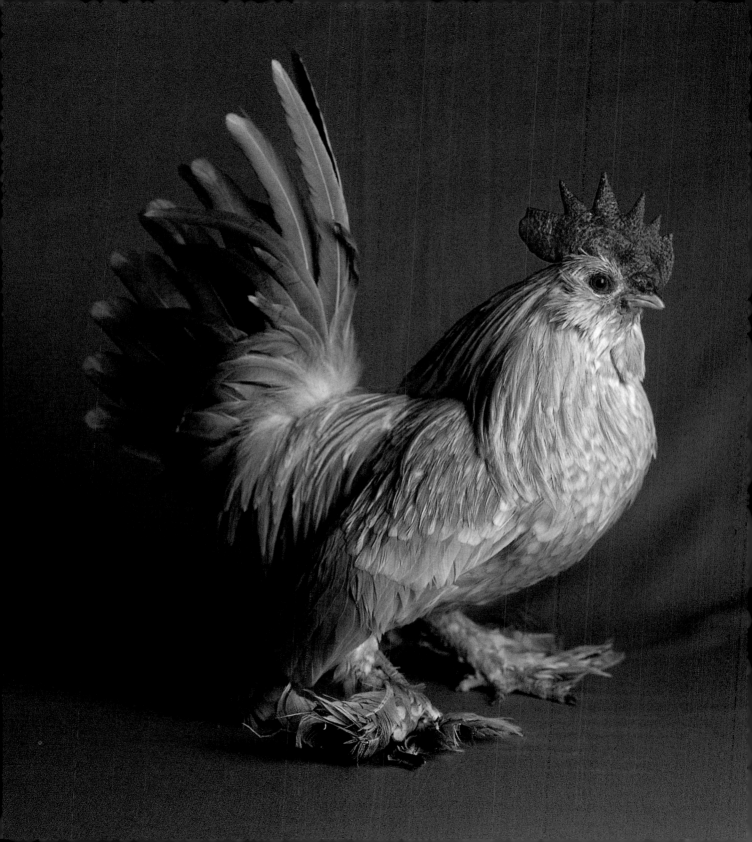

ORIGIN The name of the breed is German, though the origin is really Dutch. The English later developed the spangled variety.

FEATHER PATTERN Crescent and V-shaped spangles adorn the feathers on the neck, back, breast, and body.

COLORS Silvery-white and greenish-black plumage, slate fluff, leaden blue shanks and toes, with pinkish white bottoms of the feet.

CLASS: CONTINENTAL (NORTH EUROPEAN)

Silver Spangled Hamburg Large Fowl Hen

The Hamburg's especially attractive color patterns have earned the bird popularity over the centuries. A prolific producer of eggs, the Hamburg was once commonly referred to as the Dutch Everyday Layer. The hen in this photo shows the typical shapely Hamburg body and extremely graceful carriage.

SHOWN Illini Poultry Show 1997
Belvidere, Illinois

ADMITTED to the *Standard of Perfection* in 1874.

STANDARD WEIGHTS.

Cock5 lb. Hen4 lb.
Cockerel4 lb. Pullet3½ lb.

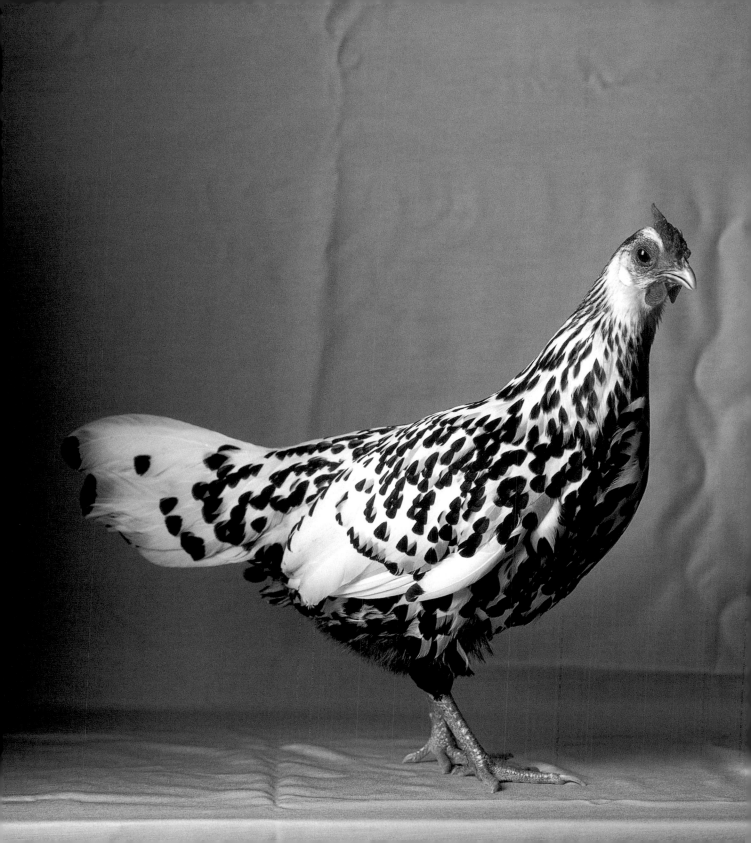

CLASS: AMERICAN

..

Dominique Large Fowl Hen

Among other things, Dominiques are valued for producing good eggs. Dominique females are medium in length, round, and compact; everything is a bit smaller in proportion than in the male. The look of these birds is solid; the disposition is steady and calm.

ORIGIN Thought to be descended from the many hawk or gray fowls kept in New England before any poultry standards existed.

FEATHER PATTERN
Feathers are crossed by irregular dark and light bars, excellence to be determined by distinct contrasts.

COLORS Slate plumage barred with colors just short of positive black and white, bright-red comb, face, wattles, and earlobes, yellow beak, reddish-bay eyes, yellow shanks and toes.

SHOWN Ohio National Poultry Show 1998 Columbus, Ohio

ADMITTED to the *Standard of Perfection* in 1874.

STANDARD WEIGHTS.

Cock7 lb.
Cockerel6 lb.

Hen5 lb.
Pullet4 lb.

84

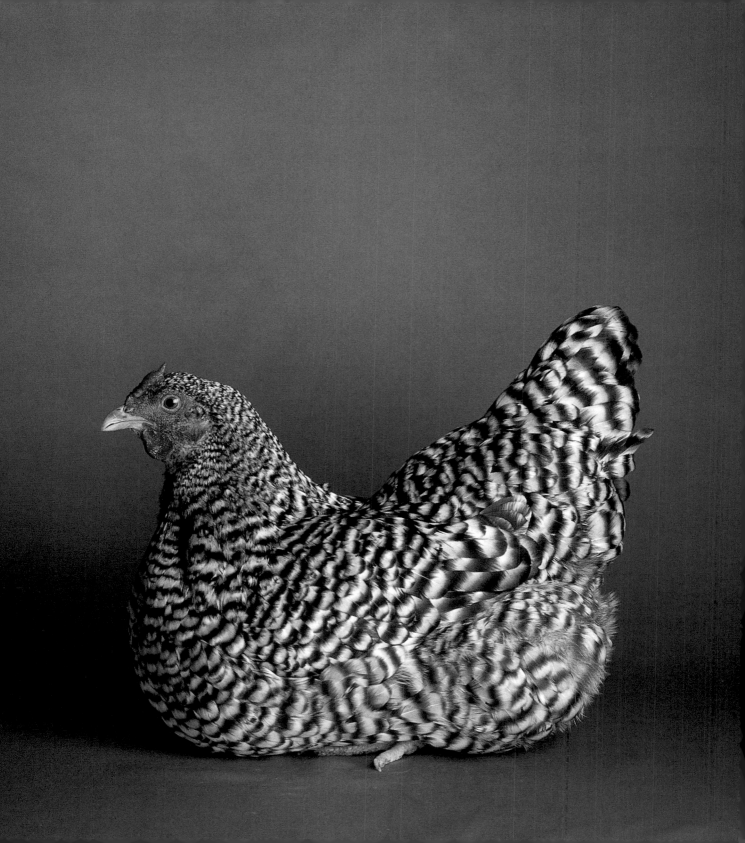

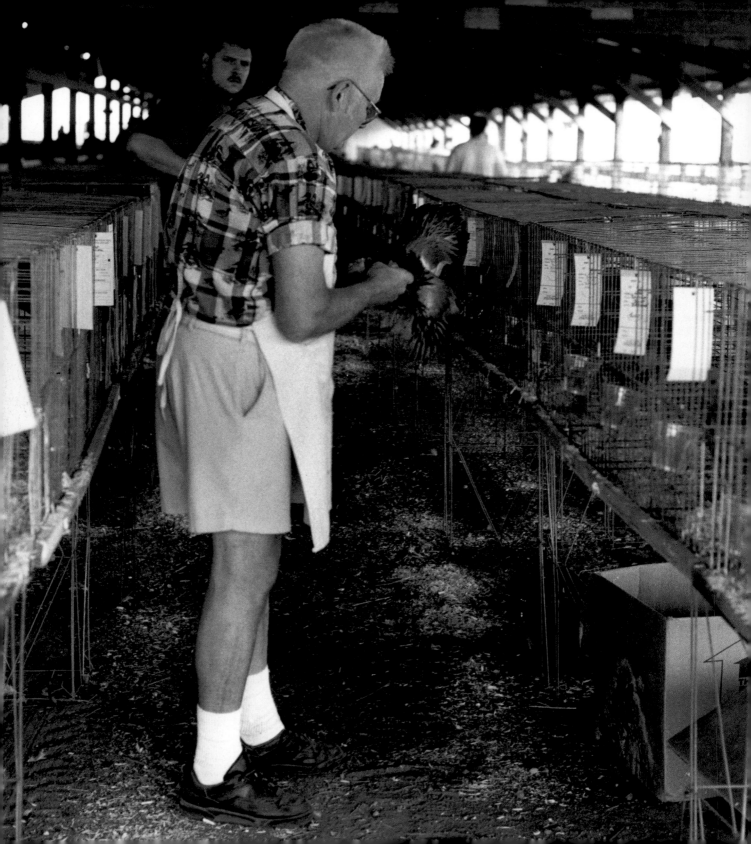

An animated discussion of poultry's finer points.

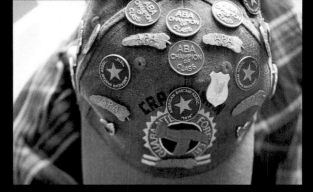

Badges of honor adorn the head of a long-time competitor.

There's all manner of poultry paraphernalia to be seen.

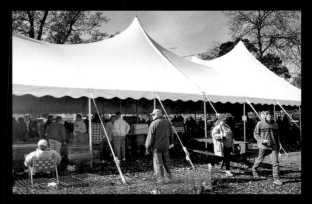

A busy day in poultry fancy— "the fancy," as it's known to insiders.

Plenty of chickens, each awaiting its moment in the spotlight.

Clubs bring enthusiasts together to encourage good-natured competition.

ORIGIN Japan, where they were originally used for cockfighting.

FEATHER PATTERN Very short, hard, closely held feathers.

COLORS Clear bluish-slate and sharp black.

CLASS: ALL OTHER STANDARD BREEDS (ORIENTALS)

Blue Shamo Large Fowl Hen

Some fanciers liken the Shamo to a bird of prey. The sparse Shamo plumage leaves considerable exposed skin, and the expression of the face is severe. This is a very tall chicken, with a muscular, meaty body that stands upright on strong legs. Of course, Shamos were bred with a purpose: they're fighters. In Japan, the law protects them from extinction.

SHOWN Ohio National Poultry Show 1998
Columbus, Ohio

Blue color not yet admitted to the *Standard of Perfection*.

STANDARD WEIGHTS.

Cock11 lb.
Cockerel9 lb.
Hen7 lb.
Pullet6 lb.

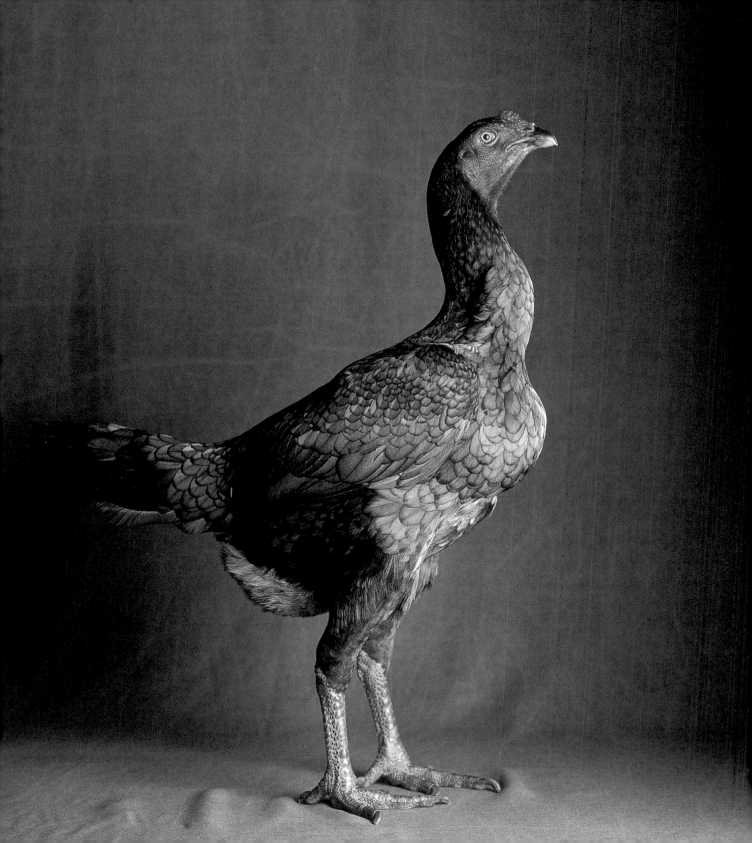

ORIGIN New York State, but known under various other names until 1883, when they became a *Standard* breed.

FEATHER PATTERN
Moderately broad and long, fitting fairly close to the body. Black with white diamond shapes, or silvery-white with black stripe, depending on the section of the body.

COLORS Silvery-white and greenish-black plumage. Undercolor of slate. Beak of dark horn, shading to yellow at point. Bright-red comb, face, wattles, and earlobes.

CLASS: AMERICAN

Silver Laced Wyandotte Large Fowl Cockerel

The Silver Laced Wyandotte began the line of many Wyandottes in different colors. This is a sharp bird, no doubt. Experts trace certain traits to Hamburgs and Dark Brahmas, but the Wyandotte now stands firmly on its own as a popular breed. Lacing, a border of contrasting color around the entire web of a feather, gives Silver Laced Wyandottes a sharp and striking appearance.

SHOWN Illini Poultry Show 1997
Belvidere, Illinois

ADMITTED to the *Standard of Perfection* in 1883.

STANDARD WEIGHTS.

Cock8½ lb.
Cockerel7½ lb.

Hen6½ lb.
Pullet5½ lb.

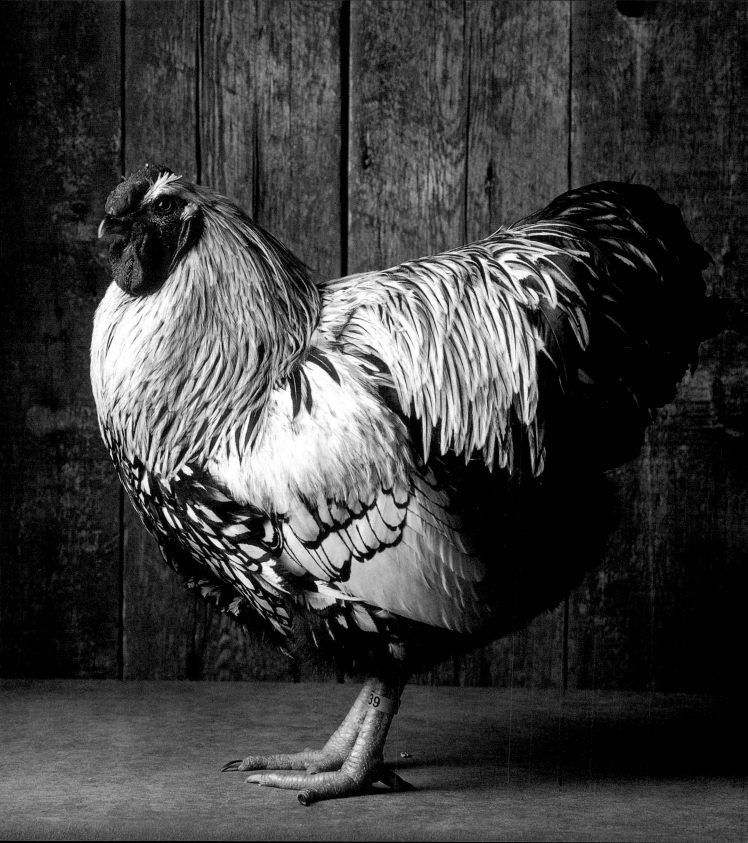

CLASS: FEATHER LEGGED BANTAMS

..

Black Cochin Frizzle Bantam Cock

The frizzle is defined by his curling feathers. Frizzle bantams can be shown in any *Standard*-accepted breed or variety. All aspects of this bird other than plumage are judged by the shape and color requirements that apply to non-frizzled Cochins.

ORIGIN China, coming to England and the U.S. in 1845.

FEATHER PATTERN Frizzle feathers are judged for uniform and complete curl.

COLORS Greenish-black plumage with slate undercolor. Bottoms of feet: yellow. Bright-red comb. Reddish-bay eyes.

SHOWN Blackhawk Poultry Show 1998 Janesville, Wisconsin

ADMITTED to the *Standard of Perfection* in 1874.

STANDARD WEIGHTS.

Cock	32 oz.
Cockerel	28 oz.
Hen	28 oz.
Pullet	26 oz.

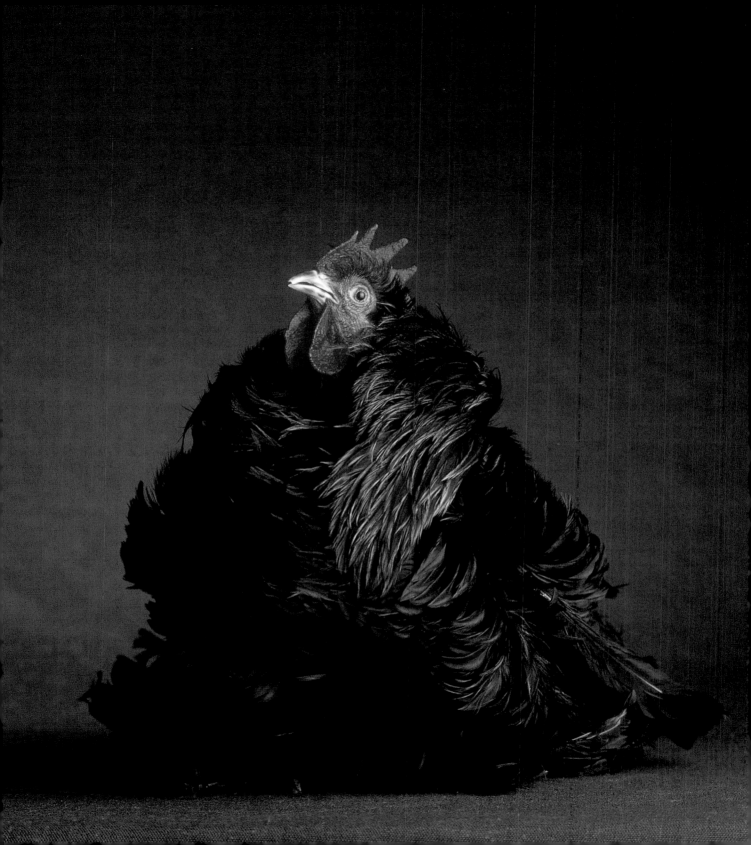

CLASS: CONTINENTAL (POLISH)

......................................

Bearded Buff Laced Polish Large Fowl Hen

This bird was previously known as Crested Dutch because of its fancy topknot. Domesticated since at least the sixteenth century, the Polish (or Crested Dutch or Padoue, as it's called in Europe) has been a long-time favorite for exhibition.

ORIGIN Eastern Europe, via England, where they became known as Poland Fowls.

FEATHER PATTERN
The crest of feathers atop the head defines both large and bantam Polish fowl.

COLORS Creamy white and golden buff laced together, beak of slate blue, eyes of reddish-bay, comb, face, and wattles of bright-red.

SHOWN Blackhawk Poultry Show 1998 Janesville, Wisconsin

ADMITTED to the *Standard of Perfection* in 1883.

STANDARD WEIGHTS.

Cock6 lb.
Cockerel5 lb.
Hen ..4½ lb.
Pullet4 lb.

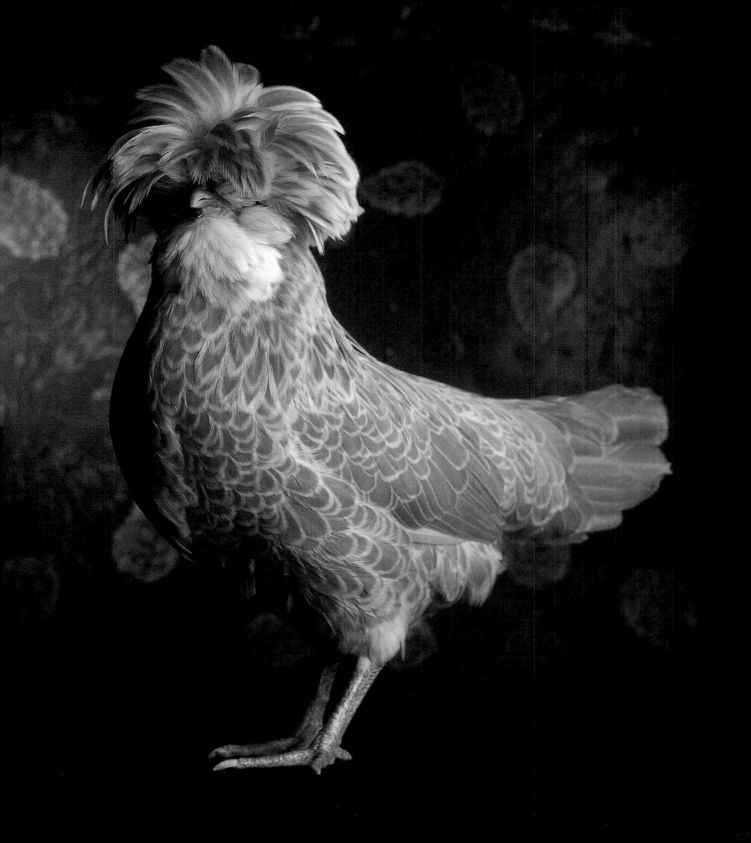

ORIGIN Eastern Hungary, though they have also been extensively bred in Germany and adjoining countries.

FEATHER PATTERN Lack of neck feathers is key. On the rest of the body, general surface color.

COLORS Naked neck is bright-red, shading to pink and yellow. Feathers are rich mahogany-bay. Slate bar on back. Red comb and face, yellow beak, shanks, and toes.

CLASS: ALL OTHER STANDARD BREEDS (MISCELLANEOUS)

Red Naked Neck Large Fowl Cock

This unusual-looking bird springs from an obscure history. Naked Necks supposedly originated in Hungary but have been favored in many other European countries for years. One reason: less plucking. Many cooks prefer the appearance of a smooth-skinned chicken.

SHOWN Indiana State Fair 1998 Indianapolis, Indiana

ADMITTED to the *Standard of Perfection* in 1965.

STANDARD WEIGHTS.

Cock8½ lb.
Cockerel7½ lb.
Hen6½ lb.
Pullet5½ lb.

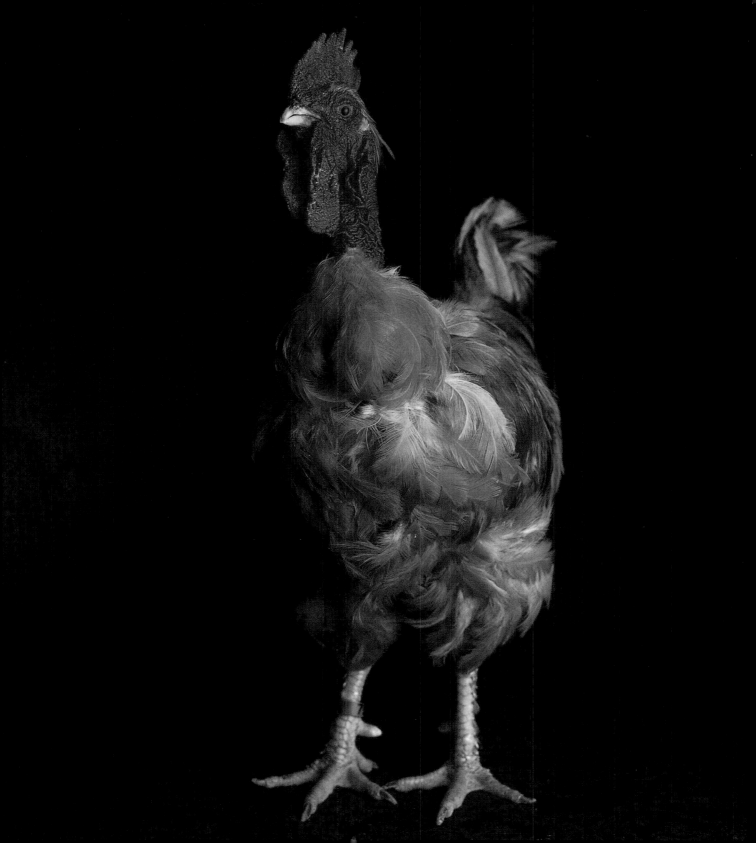

ORIGIN Japan; shown in the U.S. for about a century.

FEATHER PATTERN
On the neck hackle and saddle, a narrow strip runs through the middle of each feather and terminates in a point. On the breast, the feathers are laced with a contrasting border.

COLORS Silvery-white to glossy black plumage. Dark slate undercolor. Bright-red comb, wattles, and face. Brown eyes, yellow and dark horn beak, dusky yellow toes.

CLASS: SINGLE COMB CLEAN LEGGED (OTHER THAN GAME) BANTAMS

Gray Japanese Bantam Cock

A Japanese Bantam is a bird of extremes. The comb and head and wings and tail of the male are disproportionately large. The legs are quite exceptionally short. The tail consists of long sword shapes carried at a sharp angle.

SHOWN Illini Poultry Show 1998
Belvidere, Illinois

ADMITTED to the *Standard of Perfection* in 1914.

STANDARD WEIGHTS.

Cock 26 oz.
Cockerel 22 oz.

Hen 22 oz.
Pullet 20 oz.

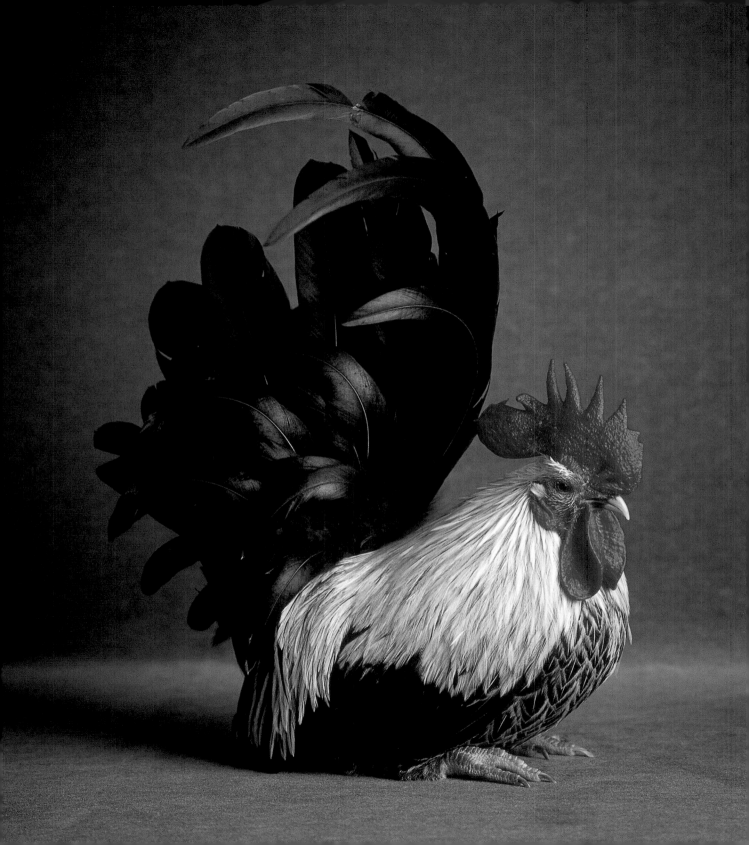

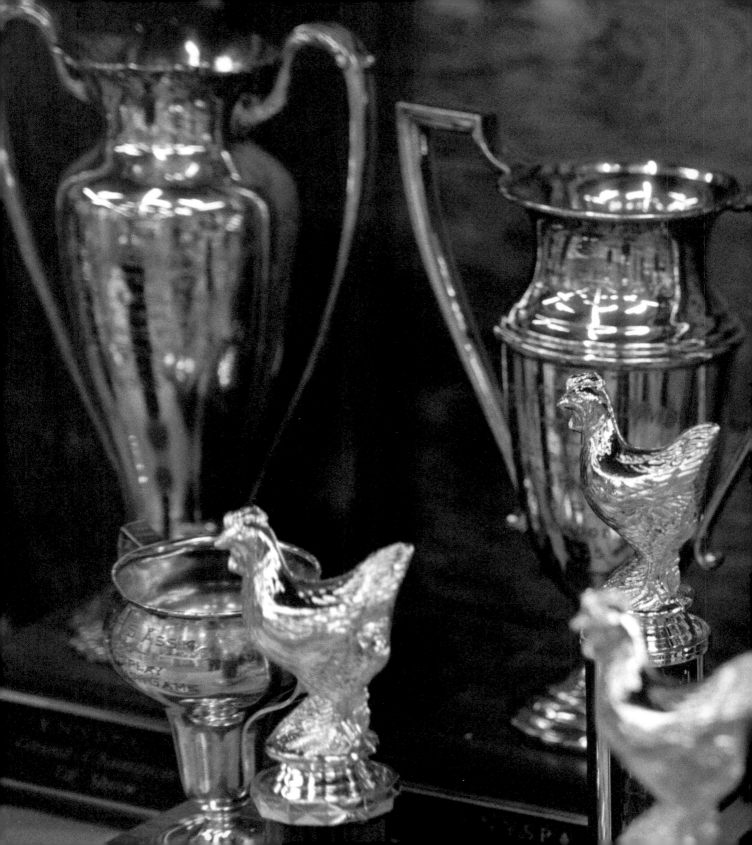

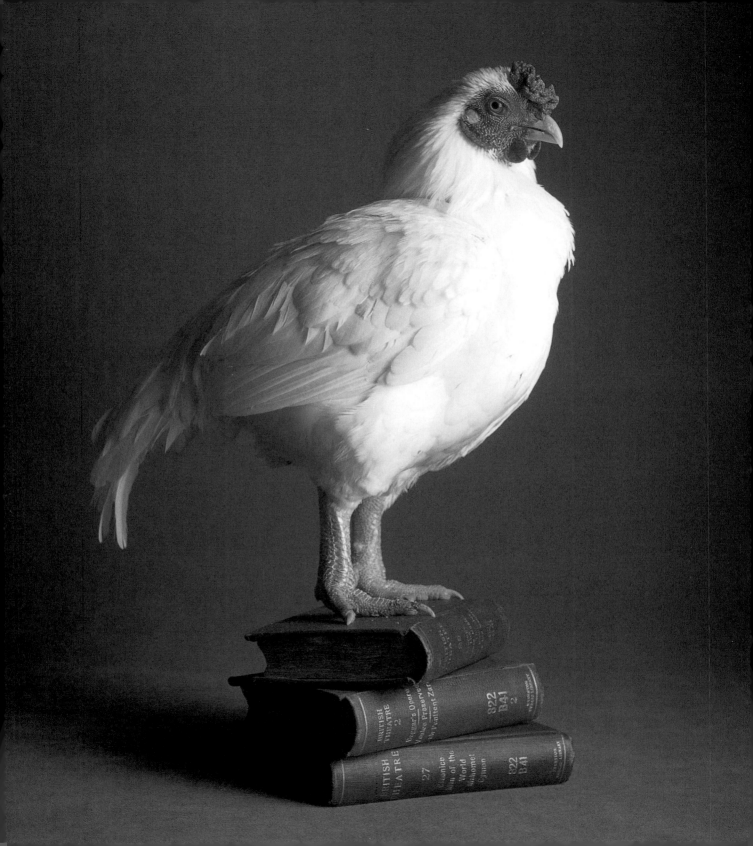

TRYING TO RESPECT A CHICKEN

Ira Glass, *This American Life,* first broadcast on December 5, 1997.

In a way, it is like Tamara Staples is running an odd little cross-species science experiment that asks this question: What happens when you try to treat a chicken the way we treat humans, even if it is just for the length of a photo shoot?

What happens, it turns out, is you learn just what the thin line is that divides human beings from birds. Maybe it's not just a thin line, but it is definitely a line. And like most city people, I had never thought about it—about where it lies, about what it might be, about what it might consist of— until Tamara and I headed out to a farm.

Outdoor sound, chickens clucking.

PAUL: "I think that is the best one."
TAMARA: "Yeah, we've got to get him. We don't want him to get dirty, do we? Or does it matter?"
PAUL: "She runs loose every day."
TAMARA: "Will we find her again? We are going to have to wrangle her, you know..."

We are at the Davidsons' dairy farm, about an hour and a half northwest of Chicago. Family members present: Paul, who is helping Tamara choose a bird to photograph; his sister Laura, who is studying photography at a nearby university; their grandfather George Cairns, a veteran breeder; and their father Dick, who seems the most skeptical of this whole project. But he patiently shows Tamara and her assistant the milking barn as a possible place to set up and shoot.

TAMARA: "It is a study of the birds, but it is an isolated study so people aren't necessarily associating them with the farm and something to eat."

This does not seem to win over the farmers, so Tamara takes us all outside the barn and shows us her shots; as she does, she drops the names of some big chicken people, people whose birds she has photographed, including Bill Wulff, editor and publisher of *Poultry Press.* Dick notices that a bird in one photo has crooked toes.

IRA: "What do you guys think of the pictures?"
GEORGE: "Oh, the pictures are nice and sharp, I mean, there's nothing wrong with the pictures. If there is anything to find fault with, it's the birds."

The fact is, while city people usually go nuts when they see Tamara's pictures, a lot of chicken breeders don't like them. To understand why, to fully comprehend this little culture clash here in America, we have to leave the barnyard for a minute and flash back to something that happened back at Tamara's apartment in the city. Tamara showed me this old, red book from the turn of the century with the seal of the American Poultry Association in gold letters: *Standard of Perfection.*

Tamara flipped through the engravings and illustrations of various types and breeds. These were show chickens standing the way that chickens stand in competitions. Then Tamara pulled out

one of her own photos for comparison—to show me how her poses do not meet the *Standard*.

TAMARA: "The tail needs to be higher, she is not standing erect, chest isn't out, head needs to be up more... and you can see the shape of the chicken much better in the *Standard of Perfection* pose."

IRA: "So is that a pose that the owners would want to own a photo of?"

TAMARA: "They are very particular. They want to see their bird in the *Standard of Perfection* pose. Definitely. 'Cause that's what they've been taught from 4-H, when they were kids."

That's for them. For herself, for her city customers, she chooses personality over perfection.

Okay, back to the barnyard.

Sound of bundles of hay being tossed.

Tamara and the Davidsons decide to set up the photo session in a room that usually stores feed for the cows. It takes about 45 minutes to set this up. That 45 minutes includes dismantling and moving a wall of hay that is probably 10 feet high and 15 feet long. This takes five people. Then, in comes the power and the fancy lights and the cloth backdrop that gets hung from the steel pole. The backdrop is ironed first with an iron and ironing board brought from the city just for that purpose. It was cold, well below freezing—so cold that the Polaroid film that Tamara uses for lighting tests does not fully develop.

TAMARA: "I just want to commune with the bird." She leans in close to the chicken. "We just want to make you pretty. Look how sweet. You know what? I am going to photograph you. My name is Tamara; I'll be your photographer for today."

Our first bird is a white Cornish, a show bird that belongs to George. Tamara has the Cornish stand up on a stack of little, red, antique books, kind of unsteady. Things go well for a while, she gets a half-dozen good shots of the bird, expressive shots... but more personality than *Standard of Perfection*, George tells me. The bird's chest isn't high enough, its body is not turned correctly to the camera. And then the bird stops cooperating. He gets tired. Paul has a suggestion:

PAUL: "Bring in a pullet."

TAMARA: "You know that works!"

IRA: "What does it mean to bring in a pullet?"

GEORGE: "We think maybe a female will perk him up."

Laura grabs a hen and waves it at the flaccid cock. The cock does not rise.

I can say that on the radio, right?

PAUL: "Laura, it would probably be better to get the one from the other pen that he's not used to."

TAMARA: "Fresh blood. Bring him around..."

IRA: "The rooster will show off more for a hen that it doesn't know?"

PAUL: "Yes. If you put him with new hens he will really show off."

They try this and that. Nothing with much success. Finally with one shot left, Paul suggests putting a hen *into* the picture with the rooster.

TAMARA: "Ooh, ooh, did you see that? She looked up at him very sweetly, like that, with her head cocked. The male bird was posing and she was posing also but had a personality of just being like the sweet, doting mother."

IRA: "But not *Standard of Perfection*?"

TAMARA: "But not *Standard of Perfection*."

Even these perfectly bred Cornishes could not achieve SOP today. And an hour of watching them makes clear just how hard it is to get the birds to hit the *Standard*. Humans have created a standard of what it means to be a chicken—a standard that most chickens can never meet. We judge them as chickens and we find them lacking. If they had the brains to understand this, they would be right to feel indignant.

But this is a city person's perspective, and it is of course completely wrong-headed from the point of view of anyone who raises birds. Standing in the cold feed room I had a long, long talk with George about this. George is 80 years old and has been raising birds since the Calvin Coolidge administration. And he says the whole fun of raising birds is raising them to the *Standard*.

George tells me that when he is breeding a new batch of birds, he'll hatch sixty-five of them and only one or two will be anywhere near the *Standard of Perfection*. That's how hard it is.

Tamara finishes hanging and lighting the next backdrop and the rest of us begin with the second bird—one called a Brahma.

IRA: "This is a chicken the size of a *dog!*"
PAUL: "Not that big."
IRA: "A small dog."

Our second bird demonstrates the great distance between bird instinct and the demands of modern fashion photography, which is to say, of civilization. Called upon to do human tasks, even rather passive ones, a bird remains a bird. Paul carries the huge chicken onto the fragile little set Tamara had built.

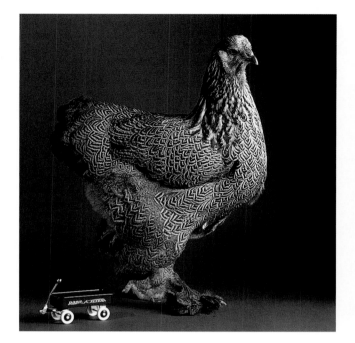

TAMARA: "He's a beauty. Whatcha eatin' there, buddy? (*A sudden flurry and snap of chicken wings.*) Ohh, he slapped me. I'm scared of this one."

She adjusts her camera. The chicken is so big— 9 pounds, the size of a small consumer turkey— that she has to pull the camera back. Then there are the props. She is trying an experiment, putting a little toy horse in the picture with the chicken, a tiny wagon. This does not seem to help things. The Davidsons are looking at her skeptically. Paul asks pointedly if she has ever shot a bird this big.

Imagine this, please, from the point of view of the chicken. You are surrounded by powerful creatures five times your height. They crowd in on you; they leer at you. You are standing on a surface, Tamara's set, where it is impossible to get decent footing. There is a 3-foot-tall strobe light—a strobe light twice your height—just a wing's length away from your beaky little face.

TAMARA: "He needs a few minutes to relax. Hello, bird. Are you going to slap me in the face again? I hope not. Let's talk. I need you to be beautiful. Here's your moment. (*Disobedient sounds from the bird.*) Okay. There are more where you came from, buddy—you'd better straighten up here."

The combination of coddling and threats might motivate an aspiring supermodel or an eager puppy, but this, after all, is a chicken. Forget *Standard of Perfection*, this chicken does not even stand up straight. It sags, it slouches. Paul tries to lure it up with a handful of corn. And somewhere during this ordeal, a funny thing happens. All of the Davidsons, who started off skeptical, are completely engaged. Dick suggests a pose that is pure art concept, a pose that could not be any further from *Standard of Perfection*. Laura lures the bird with corn. Paul smoothes feathers. Dick and various other relatives have all been standing on the edge of the feeder; now they all lean in right next to Tamara. And when the bird quivers or moves a wing, three people jump in to fix it back up.

TAMARA: "There's some feathers on the breasts, a little bit, fluffy. Okay, that looks good. He's a little too far. You guys are a great team. I am going to hire you to come with me. Okay, great. Move the hand, move the hand. Okay, great."

I realized that I came into this sort of expecting the bird to be more, well, more human. Partly, I think, because I had never thought about this one way or the other. And partly because Tamara's photos make chickens seem so thoughtful.

Those photos are a lie.

As the day continues and Tamara shoots other birds, it becomes clear. The glimpses of personality that she is able to capture on film, these are just momentary; these are fleeting. A bird turns its head for an instant at a certain angle or a bird squints his eyes at the camera, and for a moment through the camera lens, to a human, it looks like recognizable personality, emotion. But really it's just a chicken. And watching, I think I begin to understand why the people who breed birds have no interest in photos that show chickens' true personalities. It is because in their true personalities, chickens are kind of a pain in the ass. They may be capable of affection or loyalty or maybe even pride, but if so, they feel these feelings in an ancient and bird-like way, like glassy-eyed visitors from another world.

The fact is you can try to give chickens respect. You can try to treat them with dignity and photograph them the way that you would try to photograph anything serious, but the chickens will not care.

IRA: "Do you feel like your relationship with chickens has changed because of this?"
TAMARA: "No, not at all. I order the chicken when I am at the show. I eat it right in front of the chickens."
IRA: "You eat chicken while you are standing there with a chicken?"
TAMARA: "Yes! Is it wrong? I'm hungry."
IRA: "Well, no wonder they won't stand still."

We pack up our gear and move the massive wall of hay back into place. As we do this, chickens hop by, Brahmas, Ameraucanas, mixed breeds. They seem utterly uninterested in us. They cluck at each other, there's feed to eat, hay to nestle in. They have better things to do with their time. And you know, there is nothing that makes you realize just how inhuman chickens are than spending a day trying to make them seem human.

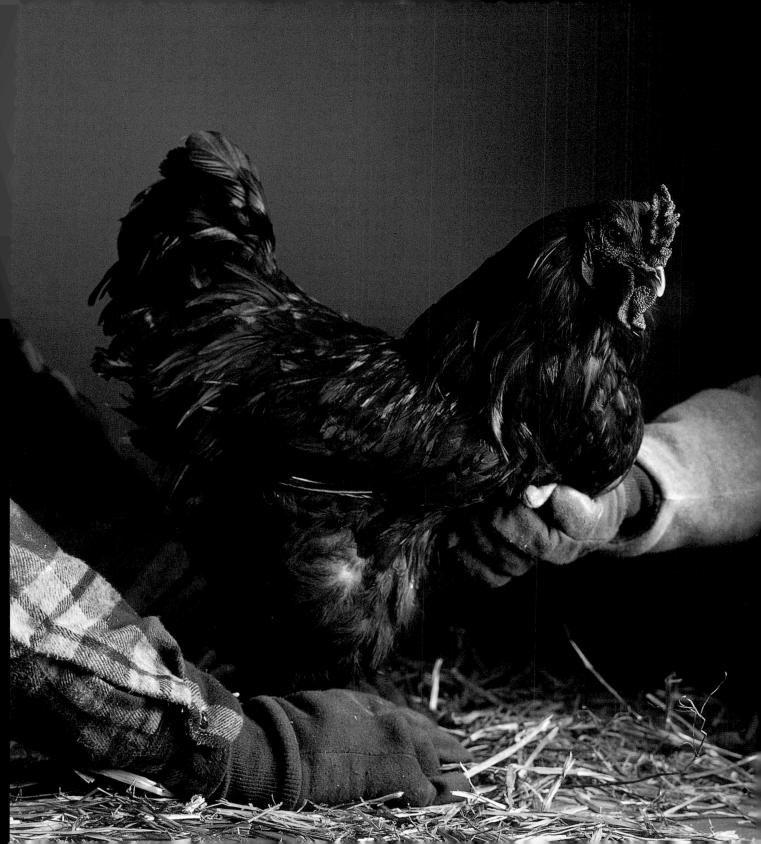